AN AMERICAN PULSE

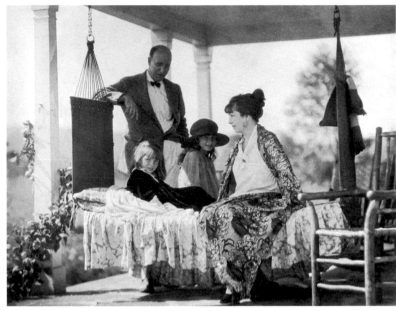

George Bellows and Emma Story Bellows seated with daughters, Jean (front) and Anne, on the porch of their summer home at Woodstock, New York, ca. 1923-24. Photo courtesy of Jean Bellows Booth.

An American Pulse: The Lithographs of
GEORGE WESLEY BELLOWS

D. Scott Atkinson

Charlene S. Engel

SAN DIEGO MUSEUM OF ART

San Diego, California

1999

This catalogue has been published in conjunction with the exhibition *An American Pulse: The Lithographs of George Wesley Bellows.*

SAN DIEGO MUSEUM OF ART
30 January - 18 April 1999

Library of Congress Cataloging-in-Publication Data

Atkinson, D. Scott, 1953-
An American pulse : the lithographs of George Wesley Bellows / D. Scott Atkinson,
 Charlene Engel.
 p. cm.
 Includes bibliographical references and index.
 ISBN 0-937-10822-7 (pbk.)
 1. Bellows, George, 1882-1925 – Exhibitions. I. Bellows, George,
1882-1925. II. Engel, Charlene S. (Charlene Stant), 1946-
III. San Diego Museum of Art. IV. Title.
NE2312.B44A4 1999
769.92–dc21 98-55490

Printed in the United States of America

Cover: George Wesley Bellows, American (1882–1925). *A Stag at Sharkey's*, lithograph, 1917. Museum purchase with funds from the Helen M. Towle Bequest, 1940:65.

Editor: Sara E. Bush
Designer: JoAnn Silva
Photographer: Philipp Scholz Rittermann

Typeset in QuarkXPress 4.0
Printed by Neyenesch Printers, San Diego, Calif.

CONTENTS

PREFACE

The late Archie Moore, better known for his left hook than his art criticism, once strolled through a museum gallery with its director. Standing before Bellows's famous depiction of the Dempsey-Firpo bout, in which the startled Champ found himself propelled through the ropes into the arms of ringside spectators, Archie paused. "You know," he mused, "you call that art. I call it a helluva punch."

Archie made a good point. Despite all the academic discourse on Bellows's classical references and technical acumen, he is proven by this collection to have been not only an adroit graphic artist, but also a masterful chronicler of what critics categorize as the "significant moment." Isolating a thundering blow from the fist of a beefy heavyweight, recording the electrifying call to the altar from a Pentecostal preacher, capturing a youth's dive from a splintered wharf into the muddy surge of the Hudson, or rendering sensitive, intimate portraits of members of his family—Bellows remains among those rare artists capable of portraying timeless moments that capture not only the immediate gesture but also the era in which it was made.

That is no small compliment. In this age of artistic pretension, hollow effort, and shrill polemic, Bellows stands out as a master at cutting through the flotsam of obscure meaning in order to get to the point. These are images of gritty evocation and acute observation, devoid of obfuscation or heavy-handed symbolism.

This is the quality that drew me to Bellows's lithographs in the first place. A couple of years ago, when I was offered the core of this Bellows collection, I jumped at the opportunity. Now, with the addition of a number of important works, this museum has one of the most complete representations of Bellows prints in the nation, and with the care of a dedicated curator and the support of a healthy endowment, the collection is in good hands for the future.

These works deserve the attention that this catalogue affords. For, like Luis Firpo in that famous moment, Bellows continues to pack quite a punch.

Steven L. Brezzo
Director
San Diego Museum of Art

Moreover, I am appreciative of Janet Ruggles, director of the Balboa Art Conservation Center, for providing counsel and conservation treatment that will benefit the lithographs, for the current exhibition and the enjoyment of future generations.

I wish to thank the following staff members of the San Diego Museum of Art for their part in the successful completion of this project: Dr. Caron Smith, deputy director for administration, for the encouragement needed to produce this publication; Sara E. Bush, coordinator of curatorial affairs, for her editorial wisdom and adroit management of the publication through production; David L. Kencik, administrative assistant, collections and rights and reproductions, for his valuable procurement of documentation and photography; JoAnn Silva, graphic designer, for her elegant design of the catalogue; Dana K. M. Bottomley, associate registrar, for her care in moving and tracking the lithographs through the organizational complexities of the exhibition; Mitchell W. Gaul, deputy director for operations, and Scot Jaffe, associate designer and head of installation, for their handsome exhibition design; and Erick Gude, preparator, for his responsible installation of the exhibition. To each and every one, I extend my most sincere gratitude.

D. Scott Atkinson
Curator of American Art
San Diego Museum of Art

AN AMERICAN PULSE

D. Scott Atkinson

> *It seems to me that an artist must be a spectator of life; a reverential,*
> *enthusiastic, emotional spectator, and then the great dramas of human*
> *nature will surge through his mind.*
>
> George Bellows, 1917

Bellows's declaration, woven into an article grandly titled, "The Big Idea: George Bellows Talks About Patriotism for Beauty," reflects accurately the verve and spirit of the artist's convictions.[1] As a reverential, enthusiastic, emotional spectator of life, Bellows transformed some of the great dramas of human nature into some of the most important works of art produced in the United States during the first quarter of the twentieth century. His prints and paintings are marked by a dynamic energy, and portray the nobility and heroic quality of the everyday world that surrounded him—industrial scenes, popular activities, city streets. Bellows became the principal beneficiary of the artistic legacy of postbellum America—realism. He, more than any artist of his generation, inherited the traditions of the great American painters of the previous century. Yet, his primary contribution to American art was his reinvention of this tradition as the first avant-garde American movement of the twentieth century.

* * *

Bellows was born in Columbus, Ohio, in 1882. His father was an architect and building contractor. Both of his parents originally came from eastern Long Island; his mother was descended from a long line of Montauk whaling captains. Bellows was raised in a frugal, conservative, Republican, Methodist household.

At an early age, Bellows began to draw. As his skill improved, he decided to become an artist—a notion to which he clung tenaciously throughout his childhood, much to his father's chagrin. By the time he reached high school, the activities that occupied him most were art and baseball—Bellows honed his skills as a ballplayer to such a degree that he was seriously scouted by professional teams, including the Cincinnati Reds. In 1901, Bellows enrolled at the Columbus campus of Ohio State University. This experience was significant for two reasons: it was there that Bellows received his first formal art instruction, and that he formed a lifelong friendship with his professor of English literature, Joseph Taylor.[2]

In 1904, without having graduated from Ohio State and over the strenuous objections of his father, Bellows moved to New York to pursue a career as a painter. He was soon in the midst of an indigenous avant-garde artistic movement as a part of the cadre of young painters surrounding the charismatic Robert Henri, who taught at William Merritt Chase's New York School of Art. As a teacher and a painter, Henri was the most influential artist in America at the turn of the century, and the principal champion of the new American realism.[3] He directed his students to walk the city in search of subjects and to paint what

they saw in the world around them. Only in this way could they immortalize the drama of American urban life and the democratic values that it reflected. The results were unidealized, even gritty portrayals of New York as it was being transformed into a modern metropolis of the twentieth century.

It was the somber colors and broad gestural brushwork of Dutch and Spanish old masters, especially Hals, Rembrandt, Goya, and Velázquez that Henri admired, emulated, and taught.[4] It is ironic that Henri adopted the painting techniques of the seventeenth century as a way of capturing the visual essence of what was modern. Summarizing the importance of this assimilation, John Wilmerding has written, "After 1900, Henri taught in Chase's New York School of Art and thus became an important artistic link in the tradition of dark realism inherited from the seventeenth century, reinterpreted by the nineteenth, and transmitted to the work of the young painters of the early twentieth."[5] Of Henri's numerous students, Bellows was certainly the most gifted. Despite the fact that he never studied in Europe, he seemed to comprehend the expressive power attainable through the broad handling of dark tonalities. More than his peers, Bellows understood the advantages of recasting seventeenth-century art in twentieth-century terms.

On his arrival in New York, Bellows wrote, "I found myself in my first art school under Robert Henri having never heard of him before. . . . My life begins at this point."[6] By the beginning of his second term, Bellows had advanced so quickly that Henri invited him to join the "Tuesday Evening" gatherings held at the older artist's home. Henri there reunited a circle of close friends who had attended the Pennsylvania Academy of Art in Philadelphia, including John Sloan, Everett Shinn, George Luks, and William Glackens.[7] With the addition of Bellows, this group formed the nucleus of the Ashcan school, named for its joining of a dark palette, bravura brushwork, and urban imagery.

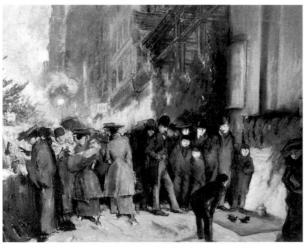

1. Everett Shinn, American (1876-1953). *Sixth Avenue Shoppers*, oil on canvas, undated. Gift of Mrs. Sterling Morton for the Preston Morton Collection. Santa Barbara Museum of Art.

The manner in which members of Henri's coterie applied his advice to paint the subjects and events they encountered while walking the city's streets, is readily apparent in Shinn's *Sixth Avenue Shoppers* (fig. 1). His masterful handling of the medium belies the lowbrow subject matter. As the pedestrians throng the busy New York avenue, a shadowy assembly of men and boys huddle in the foreground to observe a pair of fighting birds. Sloan also represented an event he obviously had encountered in one of the many

immigrant neighborhoods of lower Manhattan. *Italian Procession, New York* depicts a religious festival in Little Italy (fig. 2). This painting, contrasting the brilliantly colored banners with the dreary buildings that loom above the procession of women and girls in white, commemorates a lively event that interrupted the monotony of an otherwise drab, overcrowded neighborhood.

In 1908, Bellows responded to Henri's elevation of the commonplace by producing one of the finest Ashcan pictures, *Steaming Streets*—the quintessential expression of the style (fig. 3). A dingy, gray street covered with the slush of a melting snow was the stage on which Bellows enacted his small drama. A man struggles to control a pair of horses, which lunge toward another team of horses pulling a trolley car. From the safety of the sidewalk, onlookers lean forward, fully engaged in the spontaneous action unfolding before them. The immediacy of this exciting episode transforms the painting from an ordinary genre scene into a monumental event so full of life that we feel the cold and anticipate the sound of the whinnying horse, the admonishment of the driver, and the crunch of snow under hoof.

Given the brilliance of his execution of such scenes, Bellows rose quickly in his chosen profession, and his paintings soon received positive critical attention. In 1906, only two years after his arrival in New York, he received a gallery exhibition. In 1908, one of his pictures

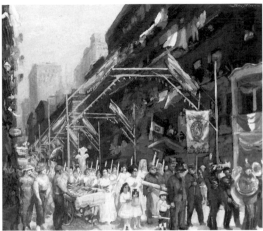

2. John Sloan, American (1871-1951). *Italian Procession, New York,* oil on canvas, 1913-25. Gift of Mr. and Mrs. Appleton S. Bridges. San Diego Museum of Art.

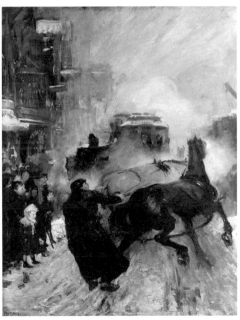

3. George Wesley Bellows, American (1882-1925). *Steaming Streets,* oil on canvas, 1908. Gift of Mrs. Sterling Morton for the Preston Morton Collection. Santa Barbara Museum of Art.

was acquired by the Pennsylvania Academy of Art; shortly thereafter another was purchased by The Metropolitan Museum of Art. In 1909, at the age of only twenty-seven, Bellows had not only learned the lessons Henri had taught him, but was surpassing the accomplishments of his former teacher. That same year he was honored as the youngest man ever to be elected an associate member of the conservative National Academy of Design.[8] With his artistic vision married to an indisputable mastery of the medium, Bellows bridged the camps of the

4. George Wesley Bellows, American (1882-1925). *Lobster Cove, Monhegan, Maine*, oil on canvas, 1913. Gift of Mrs. Henry A. Everett. San Diego Museum of Art.

art establishment and of the avant-garde. This ability resulted in Bellows being embraced as the future of American art in a way that his contemporaries were not.

In his technical facility, energy, and ability to unite art historical traditions with contemporary subjects and issues, Bellows was the direct descendent of the two artists whose careers had most completely embodied the psyche of late nineteenth-century American culture—Thomas Eakins and Winslow Homer. That Bellows deeply admired Eakins is made clear by his reaction to the 1917 exhibition held at The Metropolitan Museum of Art: "The Thomas Eakins exhibition proves him to be one of the best of all the world's masters. The greatest one man show I've ever seen and some of the very greatest pictures."[9] But it was Homer with whom Bellows felt the greatest affinity: "All the men you mention are beyond doubt great painters, great artists as well. Of them, Winslow Homer is my particular pet."[10] He carried this admiration for Homer into his painting, and his viewers took note. "Something of Winslow Homer's force I find in the work of George Bellows," observed English critic Lewis Hind in 1910, after seeing paintings by the two artists hung together.[11]

The force to which Hind was referring was Homer's ability to record not only the look but also the feel of huge breakers rolling over the rocks at Prouts Neck, Maine, where Homer had lived and worked the last two decades of his life. Documenting the dramatic moment when land and sea meet was an important subject for Bellows as well. *Lobster Cove, Monhegan, Maine* is one of his numerous paintings of the rugged Maine coast in which the force of the surging ocean tides seems palpable (fig. 4). Critical opinion continues to support Hind's conclusion. Wilmerding has noted that, "After his first summers on Monhegan Island, Bellows began to produce a number of small oil studies of surf crashing on the rocky cliffs. Not since the monumental late seascapes of Winslow Homer in the previous two decades had an American artist attained such expressive capacity with the manipulation and texture of paint."[12]

Bellows had more than just an aptitude for recording the appearance of the subject, he had an ability to impart upon it a sense of place. Wilmerding again offers the keenest insights into Bellows's ingenuity:

> Most of all, corporeal paint conveys a spirit of the here and now, which is Bellows's special accomplishment. . . . We are soon aware of his ability to use paint to record both what he saw and what he felt. . . . The literal paint describes fact . . . in a conventional sense, at the same time that it carries subjective energies . . . in a much more modern sense.[13]

One need only look at the white-gray steam rising from the vents of the newly installed urban heating system in *Steaming Streets,* or the broadly applied brush strokes forming the rocky ledge in the foreground of *Lobster Cove, Monhegan, Maine,* to see the validity of these remarks. By combining the tonal bravura of old master painting, the late nineteenth-century realism of Homer, and the modern subject matter of Henri, Bellows created a bold, often heroic art that allowed him to capture not only the outward appearances of places, people, and events, but also the fundamental vitality inherent to American life and culture.

These same qualities were also apparent in Bellows's lithographs from the beginning of their production, and remained a conspicuous part of his graphic output until his death. He exploited all of the dynamic qualities the medium had to offer. He could make the ink appear velvety in one lithograph, and grimy in another. His compositions alternated between arrangements of heavy black masses, and subtle tonal gradations. He transformed black and white into large cavernous spaces or tightly confined rooms. He knew how to leave portions of the paper untouched so that the dramatic contrast between the black ink and the white support could represent the burning intensity of white heat, or the brilliance of light. United, these characteristics allowed Bellows to produce images that conveyed dynamism, strength, and life.

By 1916, with his paintings selling steadily, Bellows had achieved a modest degree of financial success such that he could purchase a printing press and set up a lithography studio on the third floor of his home at 146 East 19th Street. For Bellows, lithography was a activity in which he could engage during the winter months, when there was insufficient light available for painting. Among his earliest lithographs is the holiday announcement, *The Studio, Christmas 1916* (Pl. 15, M. 35), revealing the degree to which art had become the primary enterprise in Bellows's home. Visible on the balcony is the lithography press being attended to by George C. Miller, Bellows's first printer. Bellows himself appears on the floor below, working on a portrait of his wife, Emma.

Lithography seems to have suited Bellows's artistic temperament; its allowance for direct expression while permitting the complete freedom to alter the results appealed to the artist's spontaneous nature. In his best prints, the gestural quality of his drawing style ranged from fluid to angular, bold to delicate, but always vital, never static. The images that resulted convey a sense of movement and power that complemented and enhanced Bellows's artistic vision.

The first and second versions of *Prayer Meeting* (Pls. 4-5, M. 13-14) of 1916, exemplify these two aspects of Bellows's style. The first state of this scene, which depicts a figure holding the congregation enraptured with his testimonial, is as sketchy as a charcoal drawing. The second, which is the same subject but reversed, is composed of smooth tonal gradations that clearly define the volume and form of the figures.

The ability to re-use the lithographic stones and the low cost of paper and ink also attracted Bellows to the medium.[14] The dramatic effects achieved through the rich contrast

of black ink on white paper had an immediate appeal for Bellows and he was soon as facile with a grease crayon as he was with a paint brush.

During the nine years Bellows was involved with lithography, he transformed it from the exclusive domain of commercial printing into a graphic medium suitable for extended artistic inquiry.[15] Bellows wrote in a 15 March 1917 letter to Joseph Taylor, "Lithographs– I have been doing what I can to rehabilitate the medium from the stigma of commercialism which has attached to it so strongly."[16] Bellows was a tireless advocate for artists, and was a founding member of the New Society of American Artists and the Society of Painter-Gravers. For the first exhibition organized by the latter group, Bellows not only provided financial backing, but also designed their new galleries.[17] His example was followed by many other young artists, who, collectively, made lithography a modern graphic method.

In his letter to Taylor, Bellows enthused about lithography:

> I draw direct on giant stones which I have invented ways and means of handling. I have a stone grinder come in to remove the old drawings and regrind the stone with proper surface, and an expert printer three nights a week to help me pull the proofs. . . . The process is chemical and not mechanical as in etching and engraving, the principal being the opposition of grease and water. We draw with sticks of grease loaded with lampblack, with greasy ink or wash on a special and rare limestone. The white parts are kept wet when inking for printing and the stone is treated with slight etch and gum arabic to reduce the grease and keep it in place.[18]

Although he turned to professional lithographers to pull the prints, Bellows clearly enjoyed the activity of making lithographs and was very much part of the process.

Bellows's lithographs were as much, if not more, about life than his paintings. The full scope of his expression in this medium ranges from the gritty but often humorous, satirical, horrifying, cruel, unjust, dramatic, theatrical, and even heroic, to the warm, familiar, and friendly. In his lithographs, Bellows became the "spectator of life" he had spoken of in 1917. His prints were expressive, informal, and direct; consequentially, they were popular images that caused excitement and received favorable reviews when exhibited. Some critics believed the lithographs to be his best work.[19] They are the record of the vibrancy, the dynamism–the American pulse–that beat at the beginning of the twentieth century. Now, at the threshold of the twenty-first century, the San Diego Museum of Art's collection of George Bellows lithographs provides an opportunity to review that record and his contribution to the history of American printmaking.

1 "The Big Idea: George Bellows Talks About Patriotism for Beauty," *Touchstone* (July 1917): 275.

2 Charles H. Morgan, *George Bellows: Painter of America* (1965; reprint, Millwood, N.Y.: Kraus Reprints, 1979), 17-35.

3 See William Innes Homer, *Robert Henri and His Circle* (1969; reprint, New York: Hacker Art Books, 1988).

4 Morgan, *George Bellows*, 39.

5 John Wilmerding, "George Bellows's Boxing Pictures and the American Tradition," in *American Views: Essays on American Art* (Princeton, N.J.: Princeton University Press, 1991), 319.

6 Quoted in Morgan, *George Bellows*, 37.

7 Ibid., 45.

8 Frank Crowninshield, "Introduction," in *George Bellows Memorial Exhibition, 1882-1925* (New York: Metropolitan Museum of Art, 1925), 13.

9 Quoted in Morgan, *George Bellows*, 215.

10 Ibid., 272.

11 Quoted in Bruce Robertson, *Reckoning with Homer: His Late Paintings and Their Influence* (Cleveland: Cleveland Museum of Art, 1990), 95.

12 Wilmerding, "George Bellows's Boxing Pictures," 323.

13 Ibid., 327.

14 Lauris Mason, with Joan Ludman, *The Lithographs of George Bellows: A Catalogue Raisonné*, rev. ed. (San Francisco: Alan Wofsy, 1992), 21-22.

15 Carl O. Schniewind, "George Bellows: Lithographer and Draftsman," in *George Bellows: Paintings, Drawings and Prints* (Chicago: The Art Institute of Chicago, 1946), 31.

16 Quoted in ibid., 33.

17 Jane Myers and Linda Ayres, *George Bellows: The Artist and His Lithographs* (Fort Worth: Amon Carter Museum, 1988), 129.

18 Quoted in Schniewind, "George Bellows," 33.

19 Myers and Ayres, *George Bellows*, 130.

GEORGE BELLOWS AND LITHOGRAPHY:
A Graphic Eye Containing Multitudes
Charlene S. Engel

Do I contradict myself?
Very well then I contradict myself,
(I am large, I contain multitudes.)
Walt Whitman, *Song of Myself*

INTRODUCTION

George Bellows's career–spanning a little over twenty years from his arrival in New York from Columbus, Ohio, in 1904, to his tragic early death from peritonitis subsequent to a ruptured appendix in January 1925–was brief but remarkably rich. He quickly excelled as a painter, finding early fame and financial success in memorable images of early twentieth-century America–a powerful series of boxing pictures, telling scenes of city life, rich landscapes, and perceptive portraits. But he was equally successful–perhaps even more so–as a printmaker, carrying these same American subjects into lithography.[1]

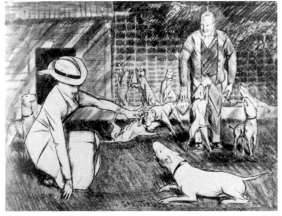

5. Illustration for "Uncle Bung" in *American*, August 1912.

In the winter of 1915-16, when Bellows began to make lithographic editions, there were relatively few American artists printing lithographs, and no independent printers in the United States with workshops catering to artists.[2] Many of the New York realists with whom Bellows was associated had experimented occasionally with printmaking, but he made it a major part of his life. Between 1916 and 1924, he produced almost 200 separate lithographic images of subjects as varied as those he treated in his paintings.[3]

Bellows promoted the medium of lithography to other artists through public demonstrations, as a founding member of the Society of Painter-Gravers and an organizer of its first two exhibitions, and perhaps most importantly, by serving as an example of a successful artist who exhibited and sold lithographs as a regular part of his profession.[4]

Bellows's gifts as a draftsman carried over from his drawings to his prints, and throughout his career Bellows the painter and Bellows the draftsman were in constant dialogue. Forceful drawing was the basis for the style of his early paintings. Even his early work shows his interest in compositional structure (fig. 5).[5] His understanding of images in black and white–his graphic eye–was extraordinarily keen, and he was able to translate values into color and draw with juicy paint as well as any American artist ever has. Drawing was Bellows's way of thinking about what he saw–analyzing, articulating, demonstrating it. Because lithography is so appropriate for the direct translation of drawing into print, it was the perfect graphic medium for him, providing both directness of effect and immediacy.

Later in his career, when he had abandoned *à la prima* painting in favor of a two-step process of paint application (hoping to emulate the old masters), drawing remained Bellows's way of articulating the world. His late drawings, such as the graphite studies for *Dempsey and Firpo*, his 1924 prizefight painting, and the late nudes, drawn directly on the stone with lithographic crayon, are models of elegance and clarity. The late lithographic portraits, such as the study of his younger daughter, *Jean 1923* (Pl. 41, M. 138), add clarity and

solidity to his dynamism and acuity of vision without any loss of energy.

The relationship among Bellows's drawings, paintings, and prints was often extremely complex. Early drawings often served as the source for illustrations, paintings, and lithographs, and lithographs played a role in his development of ideas for paintings. *Splinter Beach* (Pl. 13, M. 28) is a case in point. It began in 1913 as a drawing of young city boys swimming and lounging on a dock under the Brooklyn Bridge (an idea related to two earlier paintings, *River Rats* of 1906 and *Forty-two Kids* of 1907). The drawing became an illustration that appeared in *The Masses* in the same year (fig. 6). Then, in 1916, Bellows returned to the

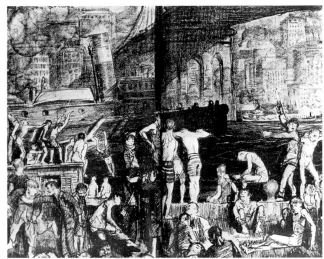

6. Illustration in *The Masses*, July 1913.

drawing to produce one of his early lithographs, *Splinter Beach*. A closely related painting, *River-Front No. 1* had been produced in 1915; this became the lithograph *River-Front* (Pl. 50, M. 168) in 1923. Finally, this composition was reworked the next year into another painting, *River-Front No. 2*.[6]

Bellows is often thought of as a realist drawing directly from the life of the city—a reporter on the scene. In fact this description is probably more appropriate for his older colleague, John Sloan. If we think of Bellows only as a realist, absorbed by the life of New York and the conflicts of the boxing ring, we ignore his determination to express more than one side of his complex and developing personality. He could have chosen to continue painting the sort of scenes that had given him his early success, but he was not content to do so; there was a romantic as well as a realist component to his psyche.[7] The later paintings cannot be explained purely as explorations in color theory or structural systems such as Dynamic Symmetry, which, in fact, was used less rigidly by Bellows than has been supposed; in his later oil paintings, he was exploring the romantic side of his personality.

We might regret that after about 1913 there are no more paintings like *Both Members of This Club* (1909), *The Lone Tenement* (1909), or *Island in the Sea* (1911), but if Bellows had not had the courage to change his painting style we would not have such pictures as *The White Horse* (1922) nor *Elinor, Jean and Anna* (1920)—one of Bellows's strongest portraits. As his painting changed, his prints became his outlet for direct drawing, and the lithographs confirm that his drawing only increased in strength as he grew older.

Bellows was a contradiction. His life defies American clichés about masculinity. He was an avid sportsman who played semi-professional baseball and basketball, and loved to read and argue about books. He was a conservative family man, but one who once roomed with Eugene O'Neill, admired the radical Emma Goldman, thought of himself as a philosophical anarchist, and contributed pacifist pictures to a socialist magazine shut down for sedition during World War I—a war in response to which he himself volunteered for the Tank Corps and produced a series of virulent war images used as propaganda pieces. He has been described as genial and aggressive, a loner, an organizer, and the ultimate team player.[8] He had a talent for friendship, making and keeping lifelong friends such as Joseph Taylor (a former teacher), Robert Henri (his mentor),

and Leon Kroll and Eugene Speicher (fellow artists). Person after person who knew him described his laugh, fondness for singing, practical jokes, immense energy, and basic decency.[9]

Fame and financial success came very early to Bellows. Even factoring in his talent, energy, and determination (all of which existed at high levels), it must be admitted that he was accepted by the art establishment with startling rapidity, while some of his contemporaries (Edward Hopper, for example) had to wait years for recognition. Although some critics found cause for complaint in his subjects, and his associations with artistic radicals made him suspicious to others, he arrived in New York at precisely the right time to be accepted as the harbinger of something new, energetic, and undeniably American. Accepted as an associate member of the National Academy in 1909–only five years after his arrival in New York–Bellows was the youngest associate ever elected, and provided a bridge between the conservative academicians and the more politically and artistically radical group centered on Henri and Sloan. Bellows seems to have been perfectly comfortable with both groups. There was nothing chameleon-like about him; he was simply able to see all sides. He served on Academy juries, moderating academic conservatism to some extent and earning a reputation for being a tough fighter for artists in whose works he believed. He explained that the humorous lithograph *The Jury* (Pl. 7, M. 17), was reminiscent of his experiences. Indeed, Bellows placed himself among the judges, smoking a cigarette at the far right behind Henri and Childe Hassam. He signed the print with a cartoon of his bald head, name, and address on the back of one of the canvases set out to be judged.[10] His progressive credentials were equally strong. He assisted with the arrangements for the Armory Show in 1913, helping to hang the avant-garde European works that turned the American art scene upside down. He also served as an art editor for *The Masses*, the almost legendary radical monthly that did much to mold the style of American magazines in the twentieth century and provided a forum for many of the country's most talented literary and artistic figures. Its contributors included Sherwood Anderson, Jack London, John Reed, Carl Sandburg, Amy Lowell, Upton Sinclair, and Max Eastman on the literary side, and Sloan, Stuart Davis, Boardman Robinson, Maurice Becker, Glenn O. Coleman, and Pablo Picasso on the artistic side.[11]

ILLUSTRATION AND LITHOGRAPHY

Bellows went to New York in 1904 with the idea of making his living as an illustrator for popular journals, as had William Glackens, Sloan, and other artists who had gone to New York from Philadelphia. At the time of his arrival, his drawing style owed much to Howard Chandler Christie and Charles Dana Gibson (of Gibson Girl fame). William Merritt Chase, head of the school where Bellows went to study, convinced the new arrival that he should consider painting, and Henri, his instructor, advised him to abandon Gibson's stylizations and to record the life in the streets around him. Bellows produced a stockpile of anecdotal drawings of city life that were full of colorful characters and incidents–a group of street urchins swimming in the East River, kids playing baseball in the street, and swarming tenement districts.[12]

According to Bellows's meticulous accounts, his first paid illustrations date to 1912, by which time he was already an associate of the National Academy.[13] His admission to the Academy was perhaps more on the grounds of his atmospheric landscapes, views of the Hudson, and studies of the enormous excavation for Pennsylvania Station, than on such powerful boxing scenes as *Both Members of This Club*.

Bellows was commissioned to illustrate most of the popular journals of the day, including the crusading muckraker periodicals that spearheaded the reform movement in America during the Theodore Roosevelt

administration. Over the years his drawings, and later his lithographs, appeared in *Hearst's International Magazine, Century, Collier's, Harper's Weekly, The Delineator, Life, Good Housekeeping, Vanity Fair, Metropolitan Magazine,* and others. Although he was paid by these publications, Bellows donated illustrations to *The Masses,* as did all its artist contributors.

When *The Masses* was founded in 1911, it became the venue for a new and almost immediately influential style of American illustration. Its visual style was planned by Sloan to resemble that of contemporary European journals, such as *Punch, Le Rire, L'Assiete au Beurre, Jugend,* and *Simplicissimus.* Its contributing artists admired such contemporary European illustrators as Jean-Louis Forain and Théophile-Alexandre Steinlen, who had devised methods for utilizing lithographic crayon to produce powerful autographic drawings using line cut, the prevalent method of reproducing black and white illustrations at that time. The contributors to *The Masses* came up with similar ways to make drawings executed with lithographic crayon reproducible by photomechanical means. Their goal was to give the effect of original lithographic drawings, like those made by Honoré Daumier, Paul Gavarni, and other illustrators in the middle of the nineteenth century.[14]

When Hutchins Hapgood became the editor of Harper's Weekly in August 1913, he embraced the style of *The Masses* and hired illustrators from its staff. As he explained:

> What we want is not what they do because there is a widespread demand for it, but . . . because it expresses them as intelligent, gifted men. It is the thing they would do for a dinner of artists in which every artist was contributing something which he knew would be appreciated by his friends but would hardly be sought by the department-store publications.[15]

Other popular magazines followed Hapgood's lead. Even *The New Yorker* ultimately owes something of its graphic style to the standard and pattern set by this short-lived but seminal magazine.

Essentially, *The Masses* offered its artists the opportunity to produce very large editions of their graphics, making fine art available–quite literally–to the masses. As many of the illustrations were made using lithographic crayon and textured paper, the experience led many artists to adopt lithography as the printmaking medium of choice, while previously only etching had been considered a graphic medium suitable for "fine art."[16] Bellows himself turned naturally to lithography as the graphic medium most suited to his talent for vigorous drawing and lively, direct expression.[17] He had previously made at least two etchings, *The Life Class* and a version of *Hail To Peace,* but preferred lithography for its directness and autographic quality. He wrote to his friend Joseph Taylor,

> I chose to lithograph instead of to etch as I like it better. It is really on the same high plane as a medium, but the mechanics are such as to drive away the artists who contemplate its use. . . . I have made one successful etching also and hope to take it up sometime.[18]

A few words must be said about lithography. It is the most autographic printmaking medium, allowing the artist to produce many impressions of an image carrying his exact handwriting–perfect for natural draftsmen such as Bellows. Unfortunately, it is also the least forgiving method of printmaking. It is a chemical process, dependent on the fact that oil and water do not mix, and not mechanical (requiring an expert hand). Lithography was the basic commercial printmaking method at the beginning of the twentieth

century and its practitioners guarded its secrets closely. There were relatively few books one could read about it; even today, books do not transmit the many subtle practices master lithographers use to coax stone and metal plates to print. There were no independent master printers working with artists. So Bellows and his contemporaries experimented on their own and cajoled commercial printers into helping them learn. For example, Sloan experimented with lithography on a press given to him by Arthur G. Dove, and worked alongside his friend, the commercial lithographer Carl Moellmann. Sloan's humorous lithograph *Amateur Lithographers* shows the two of them puffing away at pipes and struggling vigorously with a litho press. In the end, most American artists who wanted to make lithographs reconciled themselves to the need to work with a master printer.[19]

Bellows may have become acquainted with the medium through Albert Sterner, the husband of one of Bellows's dealers, Marie Sterner. Albert Sterner had studied lithography in Europe, knew Forain and Steinlen from his days in Paris, and had exhibited lithographs and monotypes through Martin Birnbaum at the Berlin Photographic Company in New York as early as 1911. It was he who introduced Bellows to George C. Miller, a young commercial lithographer with the American Lithographic Company who had been helping Sterner.[20]

While Bellows did not begin his serious involvement with lithography or purchase a press until 1916, as early as 1913 he was experimenting with printmaking techniques. In that year he contributed five illustrations to *The Masses*, four of which appear to have been made from monotypes: *Businessmen's Class, YMCA* (April 1913), *Philosopher on the Rock* (June 1913), *Splinter Beach* (July 1913), and *Why Don't They Go to the Country for a Vacation?* (August 1913). The last became the study for the painting *Cliffdwellers* (1913), and each of the other three was eventually made into a lithograph.[21]

During the winter of 1915-16, Bellows committed to the long-term exploration of lithography as a medium. He bought a press, stones, chemicals, equipment, and numerous other supplies, and set up a printmaking studio on the balcony overlooking his painting studio in his house on East 19th Street.[22] After a few attempts at printing lithographic stones by himself, he realized that the technical mysteries involved required the hand of a specialist. Miller, then twenty years old, began to print for Bellows at night at his home. One of Bellows's legacies to American printmaking is that his support made it possible for Miller to open his own shop in 1917–the first independent printshop for artistic lithography in New York. Miller printed for Bellows for only two years, but then went on to print for numerous American artists including Boardman Robinson, Arthur B. Davies, Rockwell Kent, Peggy Bacon, William Gropper, Thomas Hart Benton, and Grant Wood. He has been called the "godfather of American lithography." His son, Burr Miller, continued the shop after his father's death.[23]

Bellows recorded his printmaking efforts in his 1916 Christmas card. *The Studio, Christmas 1916* (Pl. 15, M. 35) shows the artist at work painting a portrait of Emma while his children play nearby. Above them, on the balcony can be seen his lithographic press and Miller at work. Miller was very much a part of Bellows's life that year and the next.

PRINTS OF 1916-17

Bellows's first documented lithographs were made in 1916; he identified the first as *Hungry Dogs* (Pl. 1, M. 1B).[24] Done in two separate versions on two separate stones, it had its origin in a 1907 drawing that had been reproduced in reverse in *Harper's Weekly* in September 1913 as *Dogs, Early Morning (A New York Street)*. Despite the grimness of the scene–several dogs scavenging around overflowing trash

cans–the depiction of the dogs is lively, featuring a calligraphic treatment of canine legs and haunches. As often became the case in his lithographs, Bellows used the entire picture surface, filling the foreground and background with atmospheric texture.

The trash cans in the foreground exemplify the unvarnished view of city life for which Bellows and his colleagues of the "Ashcan school" became known. In fact, this lithograph and another Bellows drawing featuring an ash can have been suggested as possible sources for the name with which the group was tagged. Referring to *Dey's woims in it* (fig. 7), a grimly humorous Bellows drawing of two scavenging characters that appeared in *The Masses* in 1914, Max Eastman, then the magazine's editor, later recalled:

> We were coarse enough to play a role in creating what has been called the Ash Can School of Art, indeed, George Bellows's revolting lithograph . . . of two bums picking scraps out of a refuse can was the *ne plus ultra* of that school.[25]

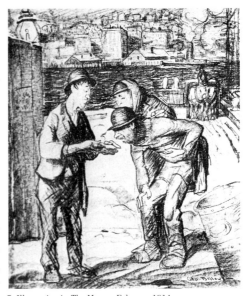

7. Illustration in *The Masses*, February 1914.

A controversy over artistic policy broke out at *The Masses* in 1916 because of an attempt by Eastman and others to take the magazine in a more overtly political direction. It led to the departure of Sloan and several other artists who did not want their pictures used for a specific political agenda. Art Young, one of the artists who remained with the magazine, remarked that Sloan's faction wanted "to run pictures of ash cans and girls hitching up their shirts in Horatio Street–regardless of ideas and without title."[26] While Bellows was associated with Sloan's faction, he nonetheless stayed with the magazine until its demise in 1917.

By his own count, Bellows produced twenty-eight lithographs in 1916.[27] Following *Hungry Dogs, Second Stone,* he apparently did a series of nudes, but he quickly began to produce more elaborate pictorial scenes. The subject matter he chose ran the gamut of his interests, and his output for the year included some of his finest prints.

In the early nudes, Bellows explored the possibilities of the lithographic medium using various drawing materials, inks, and processes. *Male Torso* (M. 2) is one of these. Emma Bellows reported that this print was made by the transfer method, and explained that "this method of transference was used only in the artist's earliest essays. All subsequent works were drawn directly on the stone."[28] *Man on His Back, Nude* (Pl. 2, M. 3) is also a transfer lithograph.

Bellows produced a number of drawings of nudes while developing the figures in the 1916 lithograph *Splinter Beach.*[29] The mood of these is one of boisterous, teeming, uncoordinated, and overflowing energy. In translating the studies into the lithograph, Bellows added and rearranged figures, and increased the amount of nudity. He often portrayed one figure looking directly at the viewer, and the partially nude boy in the left foreground pauses while taking off his clothes to look out at the viewer, as if becoming aware of an intrusion. The same boy had appeared in Bellows's 1915 painting *River-Front No. 1.*[30] The 1913 illustration in *The Masses* from which *Splinter Beach* developed had not shown this boy, but in it a seated figure at the far

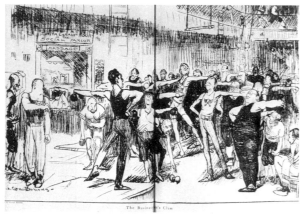

8. Illustration in *The Masses*, April 1913.

right looks out at the viewer. Bellows constantly revisited subjects and individual figures in more than one medium, reworking, updating, and altering them.

A more sedate mood is established by *In the Park, Dark* (Pl. 14, M. 30) and *In the Park, Light* (M. 31), which show more affluent New Yorkers engaged in their pastimes. Elegantly dressed ladies and gentlemen with umbrellas stroll and converse in groups or lounge on the grass while children play. The dark version of this lithograph, which was apparently done first, demonstrates greater monumentality and depth. The light version offers a variety of lithographic textures, imitating foliage in the background.[31]

Bellows based his humorous lithograph, *Business-Men's Class* (Pl. 9, M. 20), on the 1913 *Masses* illustration of the same name (fig. 8). *Business-Men's Class* pokes gentle fun at an odd assortment of ungainly businessmen working out with hand weights at the YMCA. Bellows emphasized the perfect physique and the elegant balletic stance of the instructor by showing one raised leg almost disappearing into a single sinuous line. On the other hand, the students display their too fat, too thin, too tall, too short bodies in an assortment of athletic wear, and drop their weights, suffer charley horses, wince, and otherwise struggle toward physical fitness. The lithograph demonstrates Bellows's tendency to rework an illustration to achieve greater depth and finish. The more linear illustration loses a little humor in the translation but gains three-dimensionality.

Another commentary on the quest for good health and physical beauty—this time more ironic and even a bit poignant—is provided by *Reducing, Large, Second Stone* (Pl. 10, M. 22). Based on a *Masses* illustration from November 1915, it carries the viewer into a middle-class bedroom in which a woman in nightclothes does her evening exercises on the floor while her oblivious husband sleeps. Bellows wrote of the print that it was

A study which started out in a humorous vein but developed into a drama of light and dark. The picture is as interesting upside down. Gymnastics before retiring are supposed to reduce the flesh. The husband is contented with his figure.[32]

Bellows had made a copy of Daumier's *Rue Transnonain* (1834), and critics have with some justification pointed to *Reducing*, with its dark background, view of a bed and crumpled bedclothes, and the figure on the floor with legs sprawled, as a compositional descendant of Daumier's print.[33] The exercise the woman performs pushes up her nightgown to reveal her legs and torso. Her breasts are clearly suggested under the light material of her gown. Under other circumstances, her position and partial nudity might have been sensuous, but here one thinks rather of sweat and stolid, solitary determination.

Bellows was not a conventionally religious man, but he made many lithographs dealing with religion and the ways it was practiced in early twentieth-century America. Some of these treatments are satirical, some deeply respectful. The earliest of these was done in two versions, *Prayer Meeting, First Stone* (Pl. 4, M. 13) and *Prayer Meeting, Second Stone* (Pl. 5, M. 14). These had their source in a drawing, from around 1911, that Bellows had made at a Wednesday evening religious service on Monhegan Island, Maine, on which the artist had spent several summers. This drawing had debuted as the illustration "*Deponent Testifies That He*

is No Longer a Sinner" in *Harper's Weekly* (3 January 1914). The first lithographic version is closer to the linear style of the illustration; the second is reversed, with figures redrawn, and the scene made darker so that the gas lamps on the wall seem to illuminate the room less completely.

The impressionistic *Mother and Children* (Pl. 6, M. 16), also of 1916, is a wistful portrait of Bellows's wife, Emma, with their daughters, Anne and Jean, reclining under an awning. It appeared in *The Masses* in June 1917 under the title *June Again.*

Bellows soon exhibited these lithographs. In April 1916, nine of his prints–including *Artists' Evening* (Pl. 8, M. 19), *In the Park* (both versions), *Prayer Meeting* (both versions), *Splinter Beach, Between Rounds, Large, First Stone* (M. 25), *Business-Men's Class,* and *Introducing the Champion* (M. 26)–were exhibited at Keppel & Company, along with lithographs by Bolton Brown (Bellows's future printer), and a few other American printmakers.[34]

In May 1916, two lithographs–*Artists' Evening* and *Benediction in Georgia* (Pl. 3, M. 12)–were reproduced in the journal *Arts & Decoration* as "two of the first essays in lithography done by George Bellows."[35] *Artists' Evening* was also reproduced in *The Masses* that July, under the title *At Petitpas'.*

Two more different works could hardly be imagined. *Artists' Evening* is an autobiographical look at Bellows's social milieu, and shows the artist and his friends gathered at Petipas, a popular French restaurant. The group of three standing figures at center-right shows Henri, tall and mustachioed, talking to the white-bearded Irish portrait painter John Butler Yeats (father of William Butler Yeats), who was much admired for his skills as a conversationalist. The third figure, listening to the other two, is Bellows, recognizable by his domed, balding head. Emma Bellows, elegantly poised in her chair and wearing a fashionable black hat, sits at Yeats's left.

Bellows called *Benediction in Georgia* "a satire on hypocrisy." The print shows a white preacher expounding the gospel to black convicts in leg irons, who apparently were hustled into the religious service and who listen to the preacher with expressions that range from rapt attention to despair. The strength of the drawing in the prisoners' faces and gestures demonstrates Bellows's obvious sympathy. Commenting on the print, he said that "the achievement of textures in this lithograph is a notable one among these proofs."[36] He used the blackness of the litho crayon to suggest the murky depth of the enormous, bleak room in which the sermon takes place. As a social statement, *Benediction in Georgia* is one of Bellows's most powerful works. Printmaking is a silent art, and as did silent filmmakers such as D. W. Griffith, whom he admired, Bellows exaggerated movements and gestures to emphasize emotion.[37]

Bellows is perhaps best known for his prizefight scenes, both for the great paintings such as *A Stag at Sharkey's* (1909) and *Both Members of This Club,* and for the sixteen lithographs, which were among his most popular and successful prints. In 1916, he produced five prizefight subjects. Jess Willard, shown in *Training Quarters* (M. 23), had won the heavyweight title in 1915 from Jack Johnson, the first black heavyweight champion. Willard is also shown in his corner, having his gloves put on in preparation for his championship fight with Frank Moran at Madison Square Garden on 25 March 1916, in *Introducing John L. Sullivan* (Pl. 12, M. 27). Bellows, who had seen Sullivan in the former champion's later years, described him as "a great old Viking."[38] Bellows often placed himself at ringside in his boxing pictures, and it may be his balding head that appears between Sullivan and Willard's right leg.

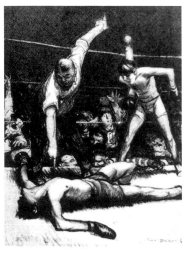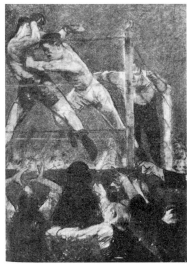

9-10. Illustrations in *American*, April 1913.

Two additional boxing lithographs, *Between Rounds, Large, First Stone* and *Introducing the Champion*, were related to illustrations Bellows had done for a story called "The Last Ounce," which appeared in *American* magazine in April 1913 (figs. 9-10). He did two versions of *Between Rounds*. The earlier version featured the use of heavy, dark crayon scraped off to create highlights in a way that suggested etching. In the later version (Pl. 43, M. 144), printed in 1923 by Bolton Brown, Bellows chose softer, more graduated values. The two prints together illustrate the technical range Bellows brought to a single subject.[39]

In his boxing prints, Bellows put as much, or more, emphasis on the excited crowd as he did on the fighters. His spectators have been compared to figures in Goya's prints and black paintings. The crowds in Bellows's lithographs are not quite so demonic or frenzied, but their exaggerated expressions and gestures convey their excitement.

Perhaps the most remarkable of the 1916 fight lithographs, and one of the finest of all Bellows's lithographs is *Preliminaries* (Pl. 11, M. 24).[40] In this print of a match that took place at Madison Square Garden, the fighters are relegated to the background, although they go at it under an intense light, and the referee strikes a dynamic pose to their left. In the foreground, wealthy socialites arrive, including several women in evening clothes. This is the only time that women appear in a Bellows boxing scene. The dense black of the men's tuxedos, the contrasting white of their shirt fronts, the dense gray of the cavernous space, and the sense of height achieved by showing a female figure in a fur stole just reaching the top step of the bleachers, combine to present an almost palpable sense of place. The final touch is the most unexpected: in the center, a woman lifts slightly the hem of her evening gown as she walks, revealing her foot and ankle. She turns her head toward the artist and viewer, curious, appraising. Although this is a complex and beautifully printed lithograph with a social dimension, what it conveys most truly is the unforgettable experience of a fleeting moment of eye contact with someone mysterious, calmly beautiful, and unobtainable.

Bellows's usual practice was to paint during the summer months when the light was good, either in New York or wherever he was vacationing, and to make prints in the late fall, winter, and early spring. He followed this practice in 1916 and in 1917. His one boxing subject of 1917 is the justly famous *A Stag At Sharkey's* (Pl. 20, M. 46), based on the 1909 painting of the same name. At the time the painting was made, public boxing matches were illegal in New York. The law was regularly circumvented by having fans and boxers pay a small fee to become members of a private club for the night (thus the titles *Club Night* and *Both Members of This Club*). The boxing rings were small, the rules loose, and the number of rounds allowed incredibly high. By 1917, the law had been changed, and boxing had become both legal and fashionable.

In *A Stag At Sharkey's*, Bellows placed himself ringside in the smoky backroom at Sharkey's Club in New York. He is probably the second fan to the right of the referee, one eye visible above the canvas, his balding head highlighted.

This print, with its monumental figures lunging and dancing in a flattened pattern of interlocking forms, rich tonal range, large size, energy, and beautiful printing, is one of Bellows's finest, and many critics count it as one of the finest prints of the twentieth century. Bellows must have realized how successful *A Stag at Sharkey's* would be, for he made ninety-nine impressions—more than he made of almost any other lithograph—and his inventory shows that it very nearly sold out during his lifetime.[41]

An equally serious and monumental print was *Dance in a Madhouse* (Pl. 23, M. 49). As a young man in Columbus, Bellows had had a friend whose father was superintendent of the state mental hospital. The drawing for *Dance in a Madhouse*—to which the lithograph remains true—dates to 1907, and had been published in *Harper's Weekly* on 23 August 1913. According to Bellows, the scene was based on the Thursday night dances held for the inmates, all of whom Bellows was able to identify. He explained that the print was intended to show "the happier side of a vast world which a more considerate and wiser society would reduce to a not inconsiderable degree."[42]

Dance in a Madhouse is the clearest example of Bellows's admiration for the work of Goya, especially in the treatment of the female figure in the left foreground who looks directly at the viewer. As her partner swings her back, her heavy body forms a strong diagonal, opposed by the diagonals formed by her arms and those of several other dancers. The energy of Bellows's images often obscures the fact that he was acutely concerned with compositional clarity. He used a full range of grays to convey the dance hall's cavernous space, with the high casement windows at the right and the tiny figures of the danceband on stage in the distance.

Perhaps the most severe print of 1917 was the *Electrocution* (Pl. 16, M. 42), which exists in five separate states. It has been suggested that the event that triggered Bellows's production of this lithograph was the death sentence handed down in the case of Thomas J. Mooney, an anarchist labor leader convicted of planting a bomb at a patriotic parade in San Francisco in 1916. Mooney's case became a rallying point for many radical groups. *The Masses* had long maintained a particularly strong opposition to capital punishment, and this print may have been Bellows's statement on the issue (fig. 11).[43] The dark tones, suitable to the grim subject matter, do not obscure the prisoner's stiffened body and clenched hand. Bellows called the print "a study of one of the most horrible phenomena of modern society."[44]

Prints in a lighter vein include *The Life Class, First Stone* (Pl. 17, M. 43), which is a gracefully designed reminiscence of Henri's evening life drawing class, and *Initiation in the Frat* (Pl. 18, M. 44), which is based on an earlier drawing recording Bellows's memories of the hazing he endured during his initiation into a college fraternity. *Initiation in the Frat* is packed with energy, incident, and detail. The foreground figures tossing a prospective fraternity brother in a blanket are shown with their muscles tense and their bodies strongly foreshortened, Bellows conveyed the energy needed to snap the blanket upward and fling its contents in the air. The subject is unusual, and,

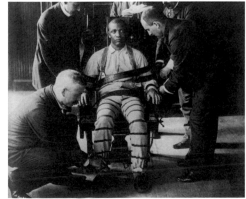

11. Execution in the U.S., early twentieth century.

17

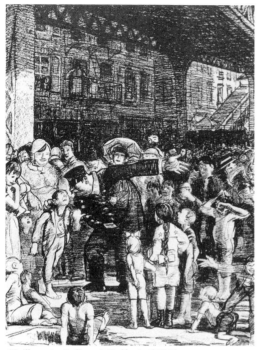

12. Illustration in *Harper's Weekly*, April 1914.

recalling Bellows's admiration for Goya, one thinks of Goya's 1792 painting *El Pelele*, which, gentler and pastel in tonality, shows a figure being tossed in a blanket by four women.[45]

Still in a humorous mood, Bellows produced the second of his YMCA lithographs, *The Shower-Bath* (Pl. 19, M. 45). Bellows called it "a humoresque of the Business men's class at the YMCA. Bathing after the gymnasium."[46] It appears that some of the same mismatched, would-be athletes of the businessmen's class have indeed moved to the pool and showers, their good cheer and determination undiminished. In this large group, Bellows's treatment of the male nude is anatomical in some cases, cartoonlike in others. Some of the poses were based on life studies while others were drawn from memory or imagination. Bellows recorded that he made thirty-six prints of *The Shower-Bath*, and while the three states of the print differ dramatically–the second state being the most finished and least cartoonlike, the third state being cut down substantially–Bellows recorded them as a single edition. Bellows often printed a lithograph on several different types of paper within a single edition. The more usual practice with etchers was to experiment with papers until arriving at the one desired, and then pull all prints within the final edition on that single type of paper. Lithography was a new art in America, and Bellows obviously enjoyed playing with the effects different papers could give him. His printer, Miller, had come out of the commercial world and did not impose a set of rules on the artist.

Like so many of Bellows's lithographs of 1917, *The Street* (Pl. 21, M. 47) had its origins as an illustration reproduced in *Harper's Weekly;* it appeared on 11 April 1914 in a story by Curt Hansen called "Fixing the Responsibility," which dealt with the animosity between a Christian boy and a Jewish boy on the Lower East Side (fig. 12). The illustration was captioned "I was beatin' 'is face," and focused on the boy explaining his actions to the policeman who has just collared him in the midst of a street crowd.

The illustration is far more linear and pictorial than the lithograph, which was redesigned and given greater spatial depth and finish.[47] In the lithograph, Bellows eliminated the policeman and substituted an angry woman. He distanced the viewer by placing the boy and the woman next to a fruit stand and surrounding them with a circle of children and other onlookers, which enlarges the depth of the print. He shifted the emphasis to two elegantly dressed women, who had barely been visible behind the policeman's left arm in the illustration. Apparently slumming, one turns to observe the argument, while the other is haughtily oblivious, her eye caught by an admiring young man tucked in the far left margin. If the illustration was an anecdotal cartoon, the print became a study in contrasts–gritty tenement life as a counterpoint to the amusements of polite society.

The *Metropolitan Magazine* in January 1915 had commissioned Bellows to travel to Philadelphia with the radical journalist John Reed (whom he knew from *The Masses* staff) to report on the revival meeting being

staged there by the evangelist Billy Sunday. The article they produced appeared in May 1915, with two drawings by Bellows and a diagram identifying the main figures. In 1916, Bellows turned one of these drawings into a painting, *Sawdust Trail*. Both drawings were then made into lithographs–*The Sawdust Trail* (Pl. 22, M. 48) in 1917, and *Billy Sunday* (Pl. 42, M. 143) in 1923. *The Sawdust Trail* is one of Bellows's larger lithographs, measuring roughly twenty-seven by twenty inches. Vertically oriented, it is split by the strong horizontal line of the stage. In the foreground, the "saved" swoon, cry, and meditate, while Sunday's assistants work the crowd. The tall balding man just to the left of center may be Bellows. Sunday himself leans over the edge of the stage to shake hands with a convert, as his wife looks on and the choir director conducts the enormous ensemble in the background.

Reed and Bellows attended several of Sunday's services, and Reed interviewed Sunday and his staff. Sunday was an ex-baseball player, and used sports metaphors liberally in his sermons. For example, in describing the story of David and Goliath: "He socked him on the coco between the lamps, and he went down for the count, after which the kid chopped off the big stiff's block."[48] Both Bellows and Reed instinctively disliked Sunday, but were fascinated by his energy and force, and worried by the uses to which his charismatic hold over his followers might be applied. Reed's article maintained a slightly humorous tone and ended, "We left yet unconverted; but there didn't seem to be anything else to do. Philadelphia was saved."[49]

Bellows was less sanguine about the revivalist preacher. In a 1917 article he explained his reservations:

> I like to paint Billy Sunday, not because I like him, but because I want to show the world what I do think of him. Do you know, I believe Billy Sunday is the worst thing that ever happened to America? He is death to imagination, to spirituality, to art. Billy Sunday is Prussianism personified. His whole purpose is to force authority against beauty. He is against freedom, he wants a religious autocracy, he is such a reactionary that he makes me an anarchist. You can see why I like to paint him and his devastating "saw-dust-trail." I want people to understand him.[50]

Bellows's reaction to Sunday is indicative of the strength of his feelings about the right of individuals to choose their own courses; orthodoxy of any sort posed a deadly threat to be countered vigorously.

BELLOWS AND THE WAR SERIES: 1918

The United States had entered World War I on the Allied side in April 1917, after maintaining its neutrality for three years. Bellows, like many Americans, had misgivings about American involvement in the war, but by 1917 he had become a strong supporter of it. Having read with outrage publications, such as the Bryce Report, on atrocities committed by German forces in Belgium, he devoted most of 1918 to a series of powerful prints and paintings documenting the effects of war.[51] Among Bellows's lithographs, only one print from before 1918 dealt with the war; *"Prepare America!"* (M. 34) from 1916 shows a girl pinning a war campaign button on a young man who raises his arms in mock surrender.

Bellows contributed illustrations for stories about the war to several magazines. He illustrated "Russia's Red Road To Berlin," for *Everybody's Magazine* (April 1915); contributed a war scene that appeared as the cover for *The Masses* (April 1915), to accompany "A War Story," by Ernest Poole (fig. 13); and provided two illustrations for a war story in the *Metropolitan Magazine* (July 1915).[52]

Bellows's ambivalence about the war can be seen in one of his two final illustrations for *The Masses*, which appeared in July 1917. One, showing Christ in chains and prison garb being persecuted for being a

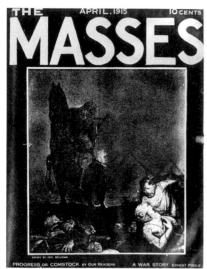

13. Cover illustration, *The Masses*, April 1915.

conscientious objector, appeared as the magazine's frontispiece (fig. 14). The same drawing had also appeared, significantly unsigned, the previous March in *The Blast*, a San Francisco anarchist periodical edited by Alexander Berkman, a colleague of Emma Goldman. The July edition of *The Masses* also featured a reproduction of the lithograph *The Street*.

The Masses vigorously opposed the war and forced conscription, and ran afoul of censorship laws when the United States entered the war. It was finally forced to cease publication when it lost its mailing privileges that August. Several of its editors and writers were tried on sedition charges and acquitted.[53] The magazine was resurrected in 1918 as *The Liberator*, which hove a bit closer to Woodrow Wilson's foreign policy, and to which Bellows also contributed illustrations (fig. 15).[54] Rebecca Zurier has written of *The Masses* and its contribution to American journalism as follows:

The Masses was unique. Existing as it did before the Bolshevik Revolution imposed a canon of political orthodoxy, *The Masses* was able freely to explore the parameters of radical culture and politics with a spontaneity and humor denied to its successors. Much error, silliness, and confusion resulted, but these hardly seem an excessive price to pay for such freedom.[55]

In July 1917–the same month in which his anti-war illustrations were published in *The Masses*–Bellows published an article in *Touchstone*. In "The Big Idea: George Bellows Talks About Patriotism for Beauty," Bellows stated:

I am a patriot for beauty . . . I would enlist in any army to make the world more beautiful. I would go to war for an ideal–far more easily that I could for a country. Democracy is an idea to me, is The Big Idea. I cannot believe that Democracy can be dropped out of existence because of the purpose of one or of many nations . . . I cannot put my finger on my war psychology at all. I can see clearly the beauty of France giving her blood for the ideal expressed in "Ma Patrie." But then, too, I can see the point of view of the Pacifist who wants to lead his life in his own way . . . but where the Patriot gets it over the Pacifist in my mind is that he does not have a chance to be a coward. And the Pacifist can be either a philosopher or a coward as his nature suggests–that is what troubles me about it.[56]

True to these sentiments, Bellows volunteered for the newly organized Tank Corps along with his friend Eugene Speicher, although the war ended before either of them was called to duty.

The war in Europe was what chiefly occupied Bellows's mind and hands in 1918. He produced a series of lithographs and followed the lithographs with paintings of several of the scenes portrayed in the prints. He had two textual sources for the series. The first was the Bryce Report, an account of atrocities committed during the German invasion of Belgium in 1914 that was based on 1,200 eyewitness accounts. It had been compiled by a committee headed by Viscount James Bryce, former British ambassador to the United States. The abridged report had appeared in the *New York Times* on 13 May 1915, and was widely circulated as powerful propaganda in support of American intervention.[57]

The second source was "The Crowning Crime," a series of articles written by Brand Whitlock, the American ambassador to Belgium between 1913 and 1917, published in *Everybody's Magazine* beginning in February 1918. The ninth and eleventh articles were illustrated with lithographs from Bellows's *War* series.[58]

Bellows's visual sources are harder to pin down. In at least one case, *Base Hospital* (M. 51-52), he noted that he had attempted to make use of photographic sources, and a number of the studies for works that became part of the *War* series suggest that Bellows made extensive use of photographic material in putting the series together.[59]

The *War* lithographs have often been compared to Goya's *Disasters of War*, which they rival for brutality. There is little doubt that Bellows knew and admired Goya's series. Like Goya's prints, Bellows's are almost impossible to look at for long. Some, such as *The Cigarette* (Pl. 26, M. 57), are difficult to look at all, featuring as they do incidents of inhuman brutality and casual violence that would be nearly incomprehensible if they had not been such frequent features of twentieth-century warfare.

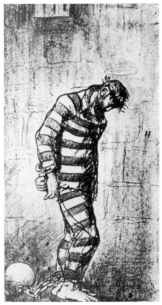

14. Illustration in *The Masses*, July 1917.

Bellows based eight of the prints directly on the Bryce Report: *Massacre at Dinant* (Pl. 25, M. 54), *The Germans Arrive* (M. 59), *The Barricade, First Stone* (M. 61), *The Last Victim* (M. 56), *The Bacchanale, First Stone* (M. 58A), *The Bacchanale, Second Stone* (M. 58B), *Belgian Farmyard* (M. 60), and *The Cigarette*. The prints in the *War* series are among his largest, and their size augments their impact. The most renowned print of the series, *Murder of Edith Cavell* (Pl. 24, M. 53) deals with the execution of a British Red Cross nurse on 12 October 1915. Cavell had been running a hospital for wounded Allied soldiers and was executed by the Germans for helping some to escape Belgium. Her execution caused an international outcry.[60] In a scene fit for the operatic stage, Bellows showed Cavell at night descending the staircase from her cell to face the firing squad (seen dimly at the right of the print), stoically accepting her unjust fate.[61]

The last print of the series was based, like the *Murder of Edith Cavell*, on Whitlock's articles. *The Return of the Useless* (Pl. 27, M. 67) showed exhausted Belgian forced laborers being returned to Belgium in boxcars late in the war. The focus is on the blond woman, at the center of the print, stepping down from the boxcar. *The Return of the Useless* was reproduced reversed in the December 1918 issue of *Everybody's Magazine*, along with the eleventh installment in Whitlock's series. The propaganda value of the *War* series was quickly appreciated, and if the war had not ended in November 1918, the prints would undoubtedly have been used extensively for propaganda purposes.[62]

Early in 1918, George Miller had closed his workshop in New York and enlisted in the Navy. The *War* series was apparently printed by Edward Krause, about whom very little is known.[63] He most likely was a commercial printer, perhaps recommended to Bellows by Miller, or perhaps even an associate of Miller. In any case, Krause was able to produce for Bellows such beautifully printed images as *Base Hospital, Second*

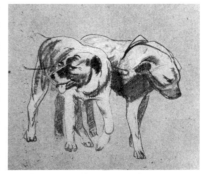

15. Illustration in *The Liberator*, July 1919.

Stone, and the monumental *Massacre at Dinant*, which, with its huddled townsmen awaiting execution and reacting with a full range of human emotions, reminds one of Rodin's *Burghers of Calais*.

Many of the prints in the *War* series have a friezelike formality new in Bellows's work. This may be because of the seriousness of the subject matter, the monumental size of many of the prints, or Bellows's study of Jay Hambidge's principles of Dynamic Symmetry. They are more akin to the symbolic figural style of artists from the 1920s, such as Rockwell Kent (a friend of Bellows), than anything that had preceded them.[64] After the end of the war, Bellows returned to many of his old subjects, but this new mood appeared again in his illustrations for two novels, Donn Byrne's *The Wind Bloweth* and H. G. Wells's *Men Like Gods*, and it informed the later portraits and beautifully drawn nudes.

The *War* series marked a watershed in Bellows's career. He was quick to qualify that the prints were aimed at the brutality of war in general and not a particular people, but they were exceptionally well appreciated for their propaganda value as well as their intensity of emotion and high quality. It was even suggested that they ought to be hung in the rooms in which the terms of peace were to be discussed.[65] They added to Bellows's already solid reputation as one of America's most serious and patriotic artists.

Bellows celebrated the return of peace after the Armistice of 11 November 1918 by reproducing as his Christmas card the second of the two murals commissioned by Helen Clay Frick in commemoration of the end of the war, *Dawn of Peace* and *Hail to Peace*.[66] It is not known who printed *Hail to Peace, Christmas 1918* (M. 68), *The Sand Team* (M. 69), a California subject from Bellows's trip to the state in 1917 that exists in only four known impressions, or *Well at Quevado* (M. 70), a small lithograph of a New Mexico subject that was also a souvenir of Bellows's trip west and that exists in only two known copies. Printing quality in all three prints is relatively low.

BELLOWS AND BOLTON BROWN

Early in 1919, Bellows met Bolton Brown, who would print the remainder of his lithographs. Brown was a remarkable character. In his fifties when he began to print for Bellows, he was a former head of the art department at Stanford University. He had already had several careers—artist, director of an utopian art school in Woodstock, New York, writer, and mountaineer (a peak in the Sierras is named Mt. Bolton Coit Brown)—when he decided, in 1915, to learn lithography so that he could produce his own prints. Unable to find anyone in the United States who could teach him artistic lithography, he embarked for London, heedless of the U-boat infested waters. He returned to the United States in May 1916, and by the beginning of 1919 had begun to print for other artists at a workshop in New York, The Artist's Press at 32 Greene Street.[67]

It is not known when exactly Bellows and Brown first met, although their work had been shown together in 1916 at Keppel & Company. It is known that they conducted a lithographic demonstration together at the Pratt Institute on 7 March 1919.[68] Brown recorded his impression of his first meeting with Bellows, arranged through one of the galleries that handled Bellows lithographs, at the artist's studio:

> I was there: prints under my arm; George of course was his usual frank and genial self. He was new to me then; I thought he had beautiful eyes. Having looked at my prints, he said: "I have the best proof puller in the American Lithographic Company, and I can't get what you get right along." I asked, "What is the matter? Can't you get what you put on the stone?" "No, that's just what we can't."[69]

When Brown began to print for Bellows, he suggested Bellows get rid of the soft, yellow lithographic stones he had been using and replace them with more fine-grained and harder gray ones. Brown identified the first print he made for Bellows as a view of Gramercy Park, but while there is a painting of Gramercy Park from 1920, no lithograph on that subject has been identified.

Bellows agreed to pay Brown a dollar per impression, more than he was paying Miller. Unlike the reticent Miller, who never signed the prints he pulled, Brown always countersigned the prints he made with Bellows and other artists. Although Miller was not known to impose his personality or suggestions on the artists for whom he printed, Brown considered printmaking to be a collaborative art. He produced his own crayons and inks, and had his own recipes and technical tricks for etching stones.[70] His very precise and orderly printing methods and his materials produced a complete range of grays, crisp prints, and great subtlety in the lighter tones. His proofs often have an almost silvery delicacy.

Miller's impressions for Bellows had provided the possibility of strong contrasts and especially rich darks. The forceful character of Bellows's early prints owed much to Miller's abilities. Brown, never excessively modest, was quick to state that Bellows had been unhappy with Miller's printing, and that he himself found it crude. But Miller had served Bellows well during the early years of his printmaking career, and whether one prefers the strong contrasts of the earlier prints or the precision and delicacy of the later prints is largely a matter of taste.[71]

BELLOWS'S LITHOGRAPHS: 1920-24

The mysterious Gramercy Park print aside, Bellows made two known prints with Brown in 1920, both with tennis as their subject. Bellows and his family had spent the summer in Middletown, Rhode Island, in 1918 and 1919, and both lithographs, *Tennis* (Pl. 28, M. 71) and *The Tournament* (Pl. 29, M. 72), show tennis matches at Newport. Bellows had worked on oils of the subjects in 1919. He himself regularly played doubles with Eugene Speicher against Leon Kroll and William Glackens on courts in New York, but in the prints he placed more emphasis on the lush surroundings (portrayed in a somewhat flattened perspective) and the activities of the spectators than on the game itself.[72]

As discussed, it was Bellows's habit to make lithographs in the winter in New York. Brown's records for winter 1921 concur with Bellows's. The two worked together between January and March to produce over fifty lithographs.[73] During 1922, Bellows recorded pulling only one print, a portrait of Mrs. Walter H. Richter (M. 131). He and Brown collaborated again between January and June 1923, and for the last time during the winter of 1923-24.[74]

The lithographs from 1921 include a great range of subjects, as if Bellows were working at white heat to turn out the greatest variety and amount he could. He printed genre subjects, nude studies, portraits, and a new set of boxing subjects. Brown's influence can easily be seen in the high quality of the printing, and even in the relaxed and sure treatment of the subject matter.

Bellows's fondness for beach scenes continued with *Bathing Beach* (Pl. 30, M. 86), a small print of a crowded beach filled with hefty figures. A couple in the foreground look up from their sunbathing, and the buxom woman smiles good naturedly at the viewer. While there is nothing profound about the subject, the print has a sunny clarity that is appealing. Earlier in his career, Bellows might have looked for a humorous angle and produced a cartoonlike treatment of this subject. Here, the subject is its own excuse.

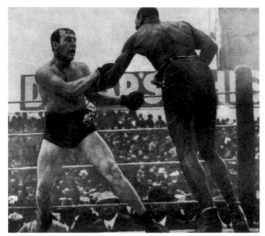

16. Jack Johnson defeating Tommy Burns in 1908, in Sydney, Australia

Among Bellows's finest lithographs of 1921 are four prints on the subject of pool (M. 81-84). These chronicle Bellows's fondness for playing that game at the National Arts Club with Henri and other artist friends.[75] The pool prints share the relaxed informality of *Bathing Beach.* They are astute, funny, and beautifully drawn, linear without being exaggerated enough to strike the viewer as cartoonlike, exhibiting a sureness and simplicity new in Bellows's work. The figure in the background shadows of *The Pool-Player* (M. 83) resembles Bellows.

The Hold-Up (Pl. 31, M. 89) was another nod to Daumier; the victim is a paunchy descendant of the French lithographer's Robert Macaire. The drawing is sketchy but sure. The print exists in two states; the first takes place during the day, the second at night. The two are remarkably different in effect. The range of grays in the first state is wide, demonstrating that Bellows took advantage of the grain of the stone and the variety of crayons Brown offered.

Each of the boxing lithographs Bellows produced in 1921 deals with the dramatic moment when one of the fighters in the ring goes down, and is based on a triangular composition.[76] *Counted Out, First Stone* (Pl. 32, M. 94) demonstrates the advantages Brown's printing brought to Bellows. Drawing with Brown's specially formulated crayons, Bellows was able to obtain a subtle range of grays from the lightest values to an inky black added with lithographic tusche (a special ink). The contrast between victor and vanquished that Bellows seems to have been seeking is especially strong in the pattern formed by the arms of the victor, the referee, and a ringside fan. This triangular composition was probably based on Hambidge's theory of Dynamic Symmetry.

Bellows incorporated the same theme into *The White Hope* (Pl. 33, M. 96), but here the subject is more complex. The print records an event that made boxing history. The downed boxer is Jim Jeffries, heavyweight champion from 1899 to 1904. The victor is the legendary Jack Johnson, the first black heavyweight champion, who won his championship in 1908 from Tommy Burns in Sydney, Australia (fig. 16). Johnson went on to defend his heavyweight title against a variety of "white hopes," one of them the aging Jeffries, whom Johnson defeated in Reno, Nevada, on 4 July 1910. The defeat of Jeffries sparked race riots across the United States, even leading to deaths in New York. For the next five years, white promoters and fans consciously sought a "white hope" who could defeat Johnson. Johnson was forced to flee the country because of legal problems, but continued to defeat challengers until 1915, when he lost his title to Jess Willard, "The Pottawattomie Giant," in a controversial bout in Havana, Cuba. The Johnson-Jeffries match took place outdoors, but Bellows portrayed it as an indoor fight so as to simplify the setting and to focus on the two boxers.[77] *Male Torso* of 1916 seems to have been used as the study for the seated Jeffries.[78]

This was not the first time a Bellows boxing picture had carried a racial subtext. *Both Members of This Club* shows a black and a white boxer in combat, and may refer to the heavyweight title being taken by Johnson the year before in Australia. The buckling knees of the bloodied white fighter are an oblique reference to the struggle to take back the title.[79]

It was only in 1921 that Bellows began to produce the portraits of his friends and family that became a central interest in his later painting and lithographs. While there are recognizable figures in many of his earlier prints, they are either famous personalities, such as Billy Sunday and John L. Sullivan, or they are portrayed as characters in situations (for example, members of an artistic jury) or colorful figures from his memory (such as in *Dance in a Madhouse*). With the exception of two group portraits of his family from 1916–*The Studio, Christmas 1916* and *Mother and Children*–he did no pure lithographic portraits before the end of World War I.

Bellows's success as a portraitist in oil had been somewhat mixed. There had been some notable successes–the two portraits of Maud Dale purchased by her husband Chester Dale in 1919, and the two portraits of the youthful Paul Clark of San Mateo, California, painted in 1917. There had also been notable disappointments, such as the failure of Ohio State University, Bellows's alma mater, to purchase his portrait of William Oxley Thompson, the university's president.[80]

In 1920, he painted *Elinor, Jean and Anna*, one of his finest portraits. It is a study of his aunt, Elinor Daggett, known as Aunt Fanny, who had encouraged his interest in art as a boy; his mother, Anna Smith Bellows; and, seated between them in a tiny chair, his younger daughter, Jean. Smiling enigmatically, Aunt Fanny looks out at the viewer and points to Jean with her hand as Anna looks on. The portrait is a study of age and youth, and has both great poignancy and strength.[81]

Henri and Bellows shared an enthusiasm for the portraits of Diego Velázquez and Frans Hals, and Bellows had gone to see the Thomas Eakins retrospective at The Metropolitan Museum of Art in 1917. Like Eakins, the subjects of Bellows's portraits were usually his family and friends. He did portraits of fellow artists Kroll, Speicher, and Henri, for example, and of their wives. *Elsie, Emma and Marjorie, Second Stone* (Pl. 35, M. 104) shows Elsie Speicher, Emma Bellows, and Marjorie Henri seated together. There are various arrangements of the women reading, lounging on divans, or reading (M. 102-7). One includes Speicher seated behind his wife and Emma. In addition, Bellows also produced an elegant study of Elsie–*Elsie, Figure* (Pl. 36, M. 109)–seated in a chair and wearing an daringly low-cut dress with her hair swept back. John Singer Sargent's portrait *Madame X* is brought to mind by the dramatic contrast between skin and silk. This print was used as a study for *Elsie, Emma and Marjorie, Second Stone*. With its simplicity and plain background, *Elsie, Figure* marks the beginning of Bellows's mature lithographic portrait style. He continued to work in a similar vein with *The Black Hat* (Pl. 37, M. 113), a fine portrait of Emma in a flowered dress wearing a large picture hat that casts her face partly in shadow. The background is left plain, and the patterns on the hat and dress balance the darkness of her sleeves and hat.

Bellows's dignified *Study of My Mother, First Stone* (Pl. 38, M. 122) shows Anna Smith Bellows much as she appeared in *Elinor, Jean and Anna*, dressed in black and seated. A second version (M. 123) places her against a darker background, which makes the cloth of her skirt seem lighter in value and heavier in weight. This second version was perhaps produced after a photograph, now in Columbus.[82]

Bellows did two versions of a portrait of the sculptor Robert Ingersoll Aitken, who had done a portrait bust of Bellows. The first (M. 126) places him in a simple though defined space. The second (Pl. 39, M. 127) has no background at all, so the emphasis is placed squarely on the sitter, whom Bellows portrayed economically, wearing a coat with a fur collar, one side of his face in shadow, the other side brightly lit. Bellows's portrait of Louis Bouché (M. 128) was likewise extremely simple and directly drawn.

Portrait of Mrs. R., an elegant portrait of the wife of print collector Walter Richter, is Bellows's only recorded lithograph of 1922. In it, the strong contrast is created by Mrs. Richter's dark clothing and hat being played against a plain background. A second portrait of her–*Study, Mrs. R.* (M. 130)–shows her wearing the same pearls and hat but placed against a dark background, and was somewhat less successful. Both probably date from the period when Mrs. Richter was sitting for her oil portrait.[83]

In 1923, Bellows continued to explore portraiture, making lithographs of the drama critic Brock Pemberton, the painter John Carroll, and the sculptor Julian Bowes. That year he also produced two of his finest portraits of his daughters. He used the same mode as in his other portraits–an extremely detailed and beautifully drawn figure against a plain background, which let the color of the paper play a role in dramatizing the print. His portrait of Jean, done in 1923, is perhaps the best of all the portraits of his daughters.

In the same year Bellows returned to the subject of evangelist Billy Sunday. Reversing the illustration, this new print–*Billy Sunday*–shows Sunday on top of two desks, his legs forming an arc, his arms stabbing the air like a boxer in battle with some unseen opponent, while his audience watches stolidly. The print shows both Sunday's power and energy. Compositionally, the greatest interest is provided by the long, thin format and the lighting, hung from roof rafters, which illuminates the cavernous space in which the revival takes place.

Bellows's one boxing picture of 1923 was *Between Rounds, Small, Second Stone*, in which Bellows focused on an exhausted boxer being revived for the next bell. It is based on a drawing Bellows did for "The Last Ounce," in the *American*, and then reworked as *Between Rounds, Large, First Stone*. A comparison of the two versions clarifies the degree to which Bellows's methods of drawing varied and the roles his printers played in his work.

Another revisited subject was *Business-Men's Bath* (Pl. 44, M. 145), based on the three versions of *The Shower-Bath* of 1917. *Business-Men's Bath* was reversed and completely redrawn as a smaller version of the earlier print. The two men whispering at the foot of the diving board have been redrawn in different positions, but much remains the same. According to Bellows's records, he had not sold many copies of the original version of the subject; his reasons for revisiting it must have been aesthetic, perhaps even from a nostalgic memory of his days living at the YMCA when he first came to New York.[84]

Bellows was commissioned to draw the crucifixion of Christ to illustrate "I Saw Him Crucified," a story by Sir Arthur Conan Doyle, the author of the Sherlock Holmes stories, which was printed in *Hearst's International Magazine* in September 1922 (Pl. 45, M. 146). Bellows's lithograph shows a debt to El Greco in the drawing of the individual figures. While Bellows was working on this lithograph and a painting on the same subject, Henri was in Spain. The two artists corresponded on their admiration for Tintoretto and El Greco, and Bellows wrote with pleasure to Henri about how his color strategy in the painting highlighted the interplay between the graphic and the painterly.

> I painted the Crucifixion complete in two colors . . . It was easy to sway a cool color a little cooler or warmer with glaze and the same for the warm. The result looking not quite full, but rather like a color print although a very good one. Then by repainting a few things, very easily and holding to the established form with a third color, a perfectly marvelous full coloration was developed strikingly like in texture the best old masters.
>
> The advantages are striking, for the first time I was able to draw very carefully with paint with the kind of freedom I have with a pencil.[85]

The lithograph, with its mannerist agitation and its carefully finished surfaces, is one of the most carefully staged of Bellows's subjects.

Another illustration project served as vehicle for the production of a powerful piece of social criticism. Bellows created *The Law is Too Slow* (Pl. 46, M. 147) for an article called "Nemesis," by Mary J. Johnston, which appeared in *Century* in May 1923. The lithograph shows a black man being burned at the stake by vigilantes after being accused of killing a white woman. In the story, all the perpetrators suffer for their actions at the hand of avenging fortune, Nemesis. In this night scene, the inky darkness around the edges of the print is contrasted with the intense light of the flames and the strong darks and lights on the prisoner's body. It would be a mistake to think that Bellows's concern for social justice declined with the demise of *The Masses;* in fact, it remained a constant until the end of his life.

Bellows's two most ambitious series of prints came out of commissions for illustrations for two books. He was asked to illustrate the serialized version of Donn Byrne's *The Wind Bloweth* for *Century* in 1922, and he redrew the illustrations into lithographs in 1923 and 1924. The pictorial treatments Bellows produced were a great success. Two of the best prints from the series are *Allan Donn Puts to Sea* (M. 152) and *The Irish Fair* (Pl. 47, M. 153). In both, Bellows arranged a large number of characters across the foreground, like so many characters on a stage. Bellows's illustrations for a second book–the futuristic fantasy by H. G. Wells, *Men Like Gods*–were done for its serialized publication in *Hearst's International Magazine* in 1923. Bellows reworked six of the illustrations as lithographs. *The Crowd* (Pl. 48, M. 162) is one of the least fantastic of the images, dramatically capturing a sense of anxiety, even of panic, in the figures pressed together against a rail. In *The Christ of the Wheel* (M. 157), also from *Men Like Gods*, Bellows re-used the figure of Christ from his illustration for *The Masses* (fig. 14).

Bellows produced an informal portrait of Eamon De Valera, the Irish patriot, in his lithograph *The Appeal to the People* (Pl. 49, M. 167). De Valera had been in the news in 1923 for having been arrested while protesting the treaty between the Irish and British governments to establish an independent, divided Ireland. De Valera is shown speaking in County Clare. A photograph of De Valera was attached to the mat on a drawing of this subject by Bellows, which provides another example of Bellows's occasional use of photographic imagery.[86]

Bellows once more returned to the composition that had its start as the illustration *Splinter Beach.* The 1915 painting *River-Front No. 1* was made into the lithograph *River-Front* in 1923, which like most printed by Brown exhibits a greater range of grays than the *Splinter Beach* of 1916.

The lithograph *The Drunk, Second Stone* (Pl. 51, M. 169B) was used as an illustration for Mabel Potter Daggett's article in support of the Prohibition Act in the February 1924 issue of *Good Housekeeping.* It exists in two versions, differing considerably, although in both the strong triangular composition shows that Bellows was still consciously using the tenets of Dynamic Symmetry. The three figures are static but in tension, and the strong emotions, the straining of the figures against one another, and the energy in their poses give the print considerable power.

In his earlier paintings and prints, Bellows seemed to emphasize the recording of events as they occurred. In *Both Members of This Club* and *The Sawdust Trail*, for example, there is a sense of looking at events in process. Later, however, Bellows seemed to become more conscious of recording history, turning to momentous events that had already taken place but that needed to be framed for posterity in some official, momentous way.

American painters, in the years around the 1913 Armory show, were exploring their option of recording the real without consciously rejecting the modern. The lines between modernism and realism had not been definitively drawn. But by 1924, an artist who chose to portray events "realistically" was aligning himself with a certain clearly defined faction and taste. Bellows unabashedly underscored his belief in the importance of the events he portrayed. The result, not only in Bellows's paintings but also in the work of Rockwell Kent and other painters of the 1920s and 1930s, was a stolid and portentous style, frozen not as a photograph freezes time, but like some tableau vivant preserving the most significant moment in a theatrical performance.

This is the case with Bellows's treatment of the famous fight between Jack Dempsey and Luis Firpo on 24 September 1923. Bellows was commissioned to draw the fight for the *New York Evening Journal*. The champion Dempsey knocked down Firpo, the Argentine challenger known as the "Bull of the Pampas," seven times in the first round—only to be floored twice himself and thrown out of the ring and into the press box. Bellows recounted to Henri, "When Dempsey was knocked through the ropes he fell into my lap. I cursed him a bit and placed him carefully back in the ring with instructions to be of good cheer."[87] Dempsey did indeed fall into the press box, but most likely Bellows was sitting, as the drawing shows, a couple of rows behind where the champion fell. In both the lithograph and the painting, he emphasized the hand of one of the members of the press corps supporting Dempsey. The outcome of the match was controversial, as it was only because Dempsey was handed back into the ring by the press that he survived the count to go on to knock Firpo out in the second round. Unfortunately, a printer's strike kept Bellows's drawing from being published in the *Journal*, but he went on to produce the painting and two lithographs–*Dempsey and Firpo* (Pl. 55, M. 181) and *Dempsey Through the Ropes* (Pl. 56, M. 182)–that focus on the figures of the two fighters.

The lithographs convey the energy and weight of the fighters. In *Dempsey Through the Ropes*, especially, there is the sense of tumbling weight collapsing on supporting hands in the press box. The excitement and unexpectedness of the scene come through. In Bellows's 1924 oil painting, *Dempsey and Firpo*, on the other hand, the event is more static and seems to be part of some unlikely choreography under the eerie green light of the ring.

Bellows varied his production of 1923-24 with a loose and experimental sketch, *Girl Fixing Her Hair* (Pl. 58, M. 184), and a view, *Sixteen East Gay Street* (Pl. 57, M. 183). The latter is a street in Columbus, near where Bellows had lived as a boy. The print is nostalgic and full of incident–people strolling, reading papers on their porches, rocking, talking, and fixing bicycles. It is a panorama of small town American life through the filter of memory.

In this period Bellows also produced some of the finest nudes of his career. His treatment of the nude varied from loosely anatomical sketches (such as the schematic productions in the *Men Like Gods* illustrations) to life drawings of the most delicate and precise accuracy. The eight nudes included in his final series (Pls. 52-54, M. 170-77) are among his finest works—convincingly real, elegant, accurate, and graceful. He used the method he had developed for some of the portraits of the previous year—isolating the figure on a plain background and thereby emphasizing the sculptural clarity. His *Nude Study, Classic on a Couch* consciously emulated a source in statuary. His *Nude Study, Woman Lying Prone* conveys both the weight borne by the woman's left arm and the sinuous length of her outstretched body.

Finally, Bellows's portraits of his daughters, Anne and Jean, are among his freshest and most direct in execution. *Sketch of Anne* (Pl. 59, M. 186) has the effect of a quick drawing, loose and calligraphic in the treatment of the hair but sure in the execution of the features. *Jean in a Black Hat* (Pl. 60, M. 187) shows his feisty younger daughter sitting ramrod straight in a black coat and hat and staring determinedly out at her father and the world.

* * *

Taken as a whole, Bellows's production as a lithographer is extraordinary in its breadth, quality, and number. The lithographs provide a clear view of the artist's character and ideas as he used lithography to explore and expand his production as an artist. It was a comfortable medium for him because of his facility as a draftsman and his familiarity with illustration. As a result, he was able to make lithographs that were informal and experimental. At the same time, however, he was able to produce some of his finest and most dramatic images. He is one of the few artists in twentieth-century America whose work in a single medium is not definitive—he was equally a painter and a graphic artist, and each medium informed the other.

Many thanks to Nancy Emerson, at the SDMA library, for generously sharing her knowledge of texts and sources; the staff at the Geisel Library at the University of California, San Diego; Rebecca Zurier and JoAnn Moser, for answering technical questions; Margo Zelinka at the Los Angeles County Museum of Art Print Room, for responding to my inquiries; Brad Delaney, for offering helpful suggestions; Grace Engel, for kindly reading the first draft and making much-needed changes; James Watrous, for introducing me to Bellows's lithographs long ago, and to whom I remain grateful; my family, for their support during this project; and to Jean Bellows Booth and Earl Booth, for their encouragement and patience in answering my questions.

1 For the best basic biography of Bellows, see Charles H. Morgan, *George Bellows: Painter of America* (1965; reprint, Millwood, N.Y.: Kraus Reprints, 1979).

2 Clinton Adams, *American Lithographers, 1900-1960: The Artists and Their Printers* (Albuquerque: University of New Mexico Press, 1983), 28; James Watrous, *A Century of American Printmaking: 1880-1980* (Madison: University of Wisconsin Press, 1984), 46.

3 For the most recent catalogue raisonné of Bellows's lithographs, see Lauris Mason, with Joan Ludman, *The Lithographs of George Bellows: A Catalogue Raisonné*, rev. ed. (San Francisco: Alan Wofsy, 1992). This updates both the 1977 edition and the still useful Emma S. Bellows, *George W. Bellows: His Lithographs*, rev. ed. (New York: Alfred A. Knopf, 1928).

4 Adams, *American Lithographers*, 31-32.

5 For Bellows's early interest in compositional schemes, see his illustrations for "Uncle Bung," *American*, August 1912, illustrated in Charlene S. Engel, "The Realist's Eye: The Illustrations and Lithographs of George Bellows," *Print Review* 10 (1979): 71. Even at this early date Bellows was gridding his composition into diamond shapes and using a triangular compositional structure. For Bellows's use of compositional systems, see Michael Quick, "Technique and Theory: The Evolution of George Bellows's Painting Style," in *The Paintings of George Bellows* (Los Angeles: Los Angeles County Museum of Art, 1992), 9-95.

6 Bellows moved certain figures from one scene to another freely. See Jane Myers and Linda Ayres, *George Bellows: The Artist and His Lithographers* (Fort Worth: Amon Carter Museum, 1988), 37-38. Several figures, including the partially clothed boy at the lower left, appear in multiple locations.

7 For example, Bellows wrote to Emma from Monhegan, "If you were with me we could tramp the wild places all day and be alone together again; and sit by the sea in the night wind; and watch the moon lay a silver carpet over the ocean. We could slip over the velvet rocks down at the sea's brink and watch the waves reach for us, and you could laugh at me for being timid and afraid of those crystal green hands . . . which are so clean and cold." Quoted in Franklin Kelly, "So Clean and Cold: Bellows and the Sea," in *The Paintings of George Bellows*, 135-69.

[60] Myers and Ayres, *George Bellows*, 64.

[61] Emma Bellows tells of her husband's fondness for musical performances. He was given season tickets to the opera in 1907 and 1908 by the wealthy mother of a friend, and liked Wagner, Puccini, Verdi, and Leoncavallo. Seiberling, "George Bellows," 221-31. The setting and the subject matter here bring to mind Act Three of Puccini's *Tosca*, which had premiered only in 1900, in which the artist Cavaradossi is brought out to face a firing squad.

[62] Myers and Ayres, *George Bellows*, 67.

[63] Ibid., 64, 66 n. 62. One impression of *A Stag at Sharkey's* carries an inscription to Krause.

[64] See, for example, Rockwell Kent's illustrations for his book *N by E* (New York: Random House, 1930).

[65] Charles Dana Gibson to Bellows, 27 August 1918, Bellows Collection, Amherst College. On the success of the *War* series, see Morgan, *George Bellows*, 220-21.

[66] Mason, *The Lithographs of George Bellows*, 128.

[67] Adams, *American Lithographers*, 32.

[68] The print pulled at Pratt was probably *The Life Class, Second Stone* (M. 8). Mason, *The Lithographs of George Bellows*, 46. For Brown's description of his first meeting with Bellows, see Myers and Ayres, *George Bellows*, 73.

[69] Myers and Ayres, *George Bellows*, 73. See also Bolton Brown, *Lithography for Artists* (Chicago: University of Chicago Press, 1930), 60.

[70] Brown has been characterized as "scholarly." Jean Bellows Booth, interview with the author, La Jolla, Calif., 16 October 1998; Mason, *The Lithographs of George Bellows*, 21-22.

[71] In Brown's unpublished journal he notes on page 756 (which is undated but comes after an entry for 28 October 1925) that he "was successful with Bellows's stones when etched." According to Clinton Adams, "The entry on page 756 is not clear as to whether the stones to which Brown refers were stones that had not previously been etched (and hence stones not printed in Bellows's lifetime) or whether they were stones that had been stored after proofing. Brown gives too little information to permit a clear understanding of the posthumous printing of the Bellows stones." Adams, *American Lithographers*, 56 n. ‡.

[72] Morgan, *George Bellows*, 245.

[73] Myers and Ayres, *George Bellows*, 73 n. 5.

[74] Ibid.

[75] Robert Henri to Bellows, quoted in Morgan, *George Bellows*, 239.

[76] Bellows's inventory shows the popularity of the boxing lithographs over his other prints.

[77] Andre and Fleischer, *A Pictorial History of Boxing*, 90-93.

[78] Mason, *The Lithographs of George Bellows*, 35.

[79] Photographs of the fight between Johnson and Burns show the similarities in height and physique of these fighters and those in *Both Members of This Club*. The original title of the painting, *A Nigger and a White Man*, reflected the racist attitudes exhibited toward Johnson by many white fans. Bellows's portrayal of the maniacal frenzy of the ringside fans may be his commentary. For a social history of boxing in American at the beginning of the twentieth century, see Marianne Doezema, *George Bellows and Urban America* (New Haven, Conn.: Yale University Press, 1992), 67-121, especially 104-13.

[80] Morgan, *George Bellows*, 177-78.

[81] On the reception of *Elinor, Jean and Anna*, see Morgan, *George Bellows*, 238, 240-41.

[82] Mason, *The Lithographs of George Bellows*, 191.

[83] It seems likely that the two portraits of Mrs. Richter were done closely together. She sat for her oil portrait in March 1922, according to Morgan, *George Bellows*, 254.

[84] See Morgan, *George Bellows*, 37-61.

[85] Bellows to Robert Henri, November 1923, Bellows Collection, Amherst College.

[86] Mason, *The Lithographs of George Bellows*, 238.

[87] Bellows to Henri, November 1923.

CHRONOLOGY

1882 Born to George Bellows, Sr., and Anna Smith Bellows, his second wife, in Columbus, Ohio on 12 August

1897-1901 Attends Central High in Columbus; plays baseball and basketball; decides to become an artist

1901-4 Attends Ohio State University; publishes cartoons in the Ohio State *Makio* and the Kenyon College yearbook; establishes friendship with Joseph Taylor; joins Beta Theta Pi fraternity; plays basketball for Ohio State; is scouted by professional baseball teams as a shortstop

1904 Leaves Ohio States at end of junior year to go to New York; enrolls in the New York School of Art; studies with Robert Henri; lives at the YMCA; plays semi-pro baseball

1905 Meets Emma Story, of Upper Montclair, N.J., a fellow student; moves to 352 West 58th St. with Ed Keefe, another student; becomes a member of Henri's "Tuesday Evening" salons

1906 Tries etching for the first time; paints *River Rats;* moves to the Lincoln Arcade Building

1907 Paints *Pennsylvania Excavation, Club Night;* does drawings *Dance in a Madhouse, Dogs, Early Morning (A New York Street),* and *Struggles with a Drunk*

1908 *North River* wings Hallgarten Prize at National Academy show; teaches at the University of Virginia in the summer; copies Daumier's *Rue Transnonain;* rooms with Eugene O'Neill

1909 Elected associate member of the National Academy of Design; sells *North River* to the Pennsylvania Academy and *Forty-two Kids* to the Carnegie Institute; paints *Lone Tenement, Both Members of This Club,* and *A Stag at Sharkey's*

1910 Teaches life drawing class at Art Students League; marries Emma Story; honeymoons at Montauk, Long Island

1911 First one-person show at Madison Gallery, New York; paints Monhegan landscapes, including *Island in the Sea;* daughter Anne born in September

1912 First journal illustrations for *The Delineator, Everybody's Magazine, Collier's, American,* and *Harper's Weekly*

1913 Helps hang the Armory Show; contributes first drawings to *The Masses;* becomes a National Academician; contributes drawings to *Harper's Weekly* and *American;* experiments with monotypes; paints *Cliffdwellers;* his father dies in March

1914 Exhibition of his paintings at the Art Institute of Chicago; drawings for the *New York Post, Arts & Decoration, Harper's Weekly,* and *The Masses*

1915 *River-Front No. 1* wins Gold Medal at the Panama-Pacific Exposition in San Francisco; summers in Ogunquit; buys lithography equipment and supplies; illustrations for *The Masses* and *Everybody's Magazine;* travels to Philadelphia with John Reed in order to illustrate story on Billy Sunday

1916 Makes lithographs with George C. Miller; exhibits lithographs at Keppel & Company; contributes illustrations and reproductions of lithographs for *Arts & Decoration, Collier's,* and *The Masses*

1917 Produces a large number of lithographs; has one-person show at Milch Gallery; visits California to carry out portrait commission; visits Henri in Santa Fe; attends lecture by Jay Hambidge; sees Eakins exhibition at The Metropolitan Museum of Art; United States enters World War I; contributes pacifist cartoon to *The Blast* and *The Masses;* writes "The Big Idea" for *Touchstone*

1918 Produces powerful series of lithographs and paintings related to World War I; applies for Tank Corps along with Eugene Speicher; war subjects reproduced in *Everybody's Magazine, Collier's, Vanity Fair,* and *The Delineator*

1919 Has one-person exhibitions in New York, Buffalo, and Chicago; participates in March in lithographic demonstration at Pratt Institute with Bolton Brown; two drawings reproduced in *The Liberator*

1920 Works with Bolton Brown on a regular basis; produces two prints related to tennis; summers in Woodstock; paints *Elinor, Jean and Anna*

1921 Produces roughly sixty lithographs with Brown; illustrations and reproductions of lithographs appear in *Life, Vanity Fair, Harper's Weekly, Century,* and *Harper's Bazaar*

1922 Builds house in Woodstock, New York; illustrations for Donn Byrne's *The Wind Bloweth* for *Century;* illustrations for H. G. Wells's *Men Like Gods* for *Hearst's International Magazine;* lithographs sell well; paints *The White Horse;* commissioned by *New York World* to draw Dempsey-Carpentier fight; lithograph *Crucifixion of Christ* appears in *Hearst's International Magazine*

1923 Anna Bellows dies in Columbus

1924 Makes over thirty lithographs with Bolton Brown in the early spring; sues *Collier's* for libel over a cropped illustration; Elinor Daggett dies; illustrations appear in *Hearst's International Magazine, Vanity Fair, Good Housekeeping, Collier's,* and the *St. Louis Post Dispatch;* diagnosed with chronic appendicitis

1925 Suffers ruptured appendix on 2 January and dies of peritonitis on 8 January; memorial exhibition at The Metropolitan Museum of Art from October through November

BIBLIOGRAPHY

ARCHIVES

Archives of American Art, Smithsonian Institution, Washington, D.C.

George Wesley Bellows Papers, Amherst College, Amherst, Mass.

George Bellows Papers, Collection of Jean Bellows Booth, La Jolla, Calif.

Charles Morgan Papers, Amherst College, Amherst, Mass.

BOOKS AND PERIODICALS

Adams, Clinton. *American Lithographers, 1900-1960: The Artists and Their Printers.* Albuquerque: University of New Mexico Press, 1983.

Adams, Clinton, and Garo Antreasian. *The Tamarind Book of Lithography: Art and Techniques.* New York: Harry N. Abrams, 1970.

Beall, Karen F., comp. *American Prints in the Library of Congress: A Catalog of the Collection.* 1970. Reprint, San Francisco: Alan Wofsy, 1991.

Bellows, Emma S. *George W. Bellows: His Lithographs,* rev. ed. New York: Alfred A. Knopf, 1928.

——. *The Paintings of George Bellows.* New York: Alfred A. Knopf, 1929.

"The Big Idea: George Bellows Talks about Patriotism for Beauty." *Touchstone* (July 1917): 269-75.

Boorsch, Suzanne. "The Lithographs of George Bellows." *ARTnews* (March 1976): 60-62.

Boswell, Peyton, Jr. *George Bellows.* New York: Crown, 1942.

Braider, Donald. *George Bellows and the Ashcan School of Painting.* Garden City, N.Y.: Doubleday, 1971.

Brown, Bolton. *Lithography.* New York: FitzRoy Carrington, 1923.

——. *Lithography for Artists.* Chicago: University of Chicago Press, 1930.

——. "My Ten Years in Lithography," *The Tamarind Papers* 5 (Winter 1981-82): 8-25, 36-54.

——. "Prints and their Makers," *Print* (November 1930): 13-24.

Catalogue of an Exhibition of Original Lithographs by George Bellows, N.A. Chicago: Albert Roullier Art Galleries, 1919.

Doezema, Marianne. *George Bellows and Urban America.* New Haven, Conn.: Yale University Press, 1992.

Eggers, George W. *George Bellows.* New York: Whitney Museum of American Art, 1931.

Engel, Charlene S. "George W. Bellows' Illustrations for *The Masses* and Other Magazines and the Sources of His Lithographs of 1916-17." Ph.D. diss., University of Wisconsin, 1976.

——. "The Realist's Eye: The Illustrations and Lithographs of George Bellows." *Print Review* 10 (1979): 70-86.

Fishbein, Leslie. *Rebels in Bohemia: The Radicals of "The Masses," 1911-1917.* Chapel Hill: University of North Carolina Press, 1973.

Fitzgerald, Richard A. *Art and Politics: Cartoonists of "The Masses" and "Liberator."* Westport, Conn.: Greenwood Press, 1973.

Flint, Janet A. *George Miller and American Lithography.* Washington, D.C.: National Collection of Fine Arts, 1976.

Francis, Henry Sayles. "The Lithographs of George Wesley Bellows." *Print Collector's Quarterly* 27 (1940): 139-65.

Frohman, Louis H. "Bellows as an Illustrator." *International Studio* 78 (February 1924): 421-25.

George Bellows Memorial Exhibition, 1882-1925. New York: Metropolitan Museum of Art, 1925.

George Bellows: Paintings, Drawings and Prints. Chicago: Art Institute of Chicago, 1946.

George Bellows and the War Series of 1918. New York: Hirschl and Adler Galleries, 1983.

Henri, Robert. *The Art Spirit.* 1923. Reprint, New York: Harper and Row, 1984.

Homage to George Bellows: Lithographs with Selected Drawings and Paintings. New York: Metropolitan Museum of Art, 1982.

Homer, William Innes. *Robert Henri and His Circle.* 1969. Reprint, New York: Hacker Art Books, 1988.

Kwait, Joseph J. "Robert Henri and the Emerson-Whitman Tradition." *Publications of the Modern Language Association* 71 (September 1956): 617-36.

Mason, Lauris, with Joan Ludman. *The Lithographs of George Bellows: A Catalogue Raisonné,* rev. ed. San Francisco: Alan Wofsy, 1992.

The Masses. New York: 1911-17. Reprint, Millwood, N.Y.: Kraus Reprints, 1980.

Maurice, Alfred P. "George C. Miller and Son, Lithographic Printers to Artists since 1917." *American Art Review* (March-April 1976): 133-44.

McBride, Henry. "Lithographs by Bellows." *New York Herald*, 17 February 1924.

Metropolitan Lives: The Ash Can Artists and Their New York. Washington, D.C.: National Museum of American Art, 1996.

Morgan, Charles H. *The Drawings of George Bellows.* Alhambra, Calif.: Borden, 1973.

——. *George Bellows: Painter of America.* 1965. Reprint, Millwood, N.Y.: Kraus Reprints, 1979.

Myers, Jane, and Linda Ayres. *George Bellows: The Artist and His Lithographs.* Fort Worth: Amon Carter Museum, 1988.

Oates, Joyce Carol. *George Bellows: American Artist.* Hopewell, N.J.: Ecco Press, 1995.

O'Neill, William L., ed. *Echoes of Revolt: "The Masses," 1911-1917.* 1966. Reprint, Chicago: Elephant, 1989.

Porter, Fairfield. "George Bellows: Journalists' Artist." *ARTnews* (February 1957): 32-35.

Quick, Michael et al. *The Paintings of George Bellows.* Los Angeles: Los Angeles County Museum of Art, 1992.

Roberts, Randy. *Papa Jack: Jack Johnson and the Era of the White Hopes.* New York: Free Press, 1983.

Seiberling, Frank, Jr. "George Bellows, 1882-1925: His Life and Development as an Artist." Ph.D. diss., University of Chicago, 1948.

Sloan, John. *John Sloan's New York Scene: From the Diaries, Notes, and Correspondence, 1906-1913.* New York: Harper and Row, 1965.

Stogdon, N. G., and Susan Lewis Kaye. *George Bellows–The Boxing Lithographs.* New York: N. G. Stogdon, 1988.

Tufts, Eleanor M. "Bellows and Goya." *Art Journal* 30, no. 4 (Summer 1971): 362-68.

——. "Realism Revisited: Goya's Impact on George Bellows and Other American Responses to the Spanish Presence in Art." *Arts Magazine* 57 (February 1983): 105-43.

Tyler, Francine. "The Impact of Daumier's Graphics on American Artists: ca. 1863-ca. 1923." *Print Review* 11 (1980): 108-26.

Wasserman, Krystyna. "George Wesley Bellows's War Lithographs and Paintings of 1918." M.A. thesis, University of Maryland, 1981.

Watrous, James. *A Century of American Printmaking, 1880-1980.* Madison: University of Wisconsin Press, 1984.

Watson, Ernest, W. "George Miller: Godfather to Lithography." *American Artist* (June 1943): 13-15.

Weitenkampf, Frank. "George W. Bellows, Lithographer." *Print Connoisseur* 4 (1924): 225-44.

Wilmerding, John. *American Views: Essays on American Art.* Princeton: N.J.: Princeton University Press, 1991.

Young, Mahonri Sharp. *The Paintings of George Bellows.* New York: Watson-Guptill, 1973.

Zurier, Rebecca. *Art for "The Masses": A Radical Magazine and Its Graphics, 1911-1917.* Philadelphia: Temple University Press, 1988.

——. "Hey Kids: Children in the Comics and the Art of George Bellows." *Print Collector's Newsletter* 18 (January-February 1988): 196-203.

PLATES

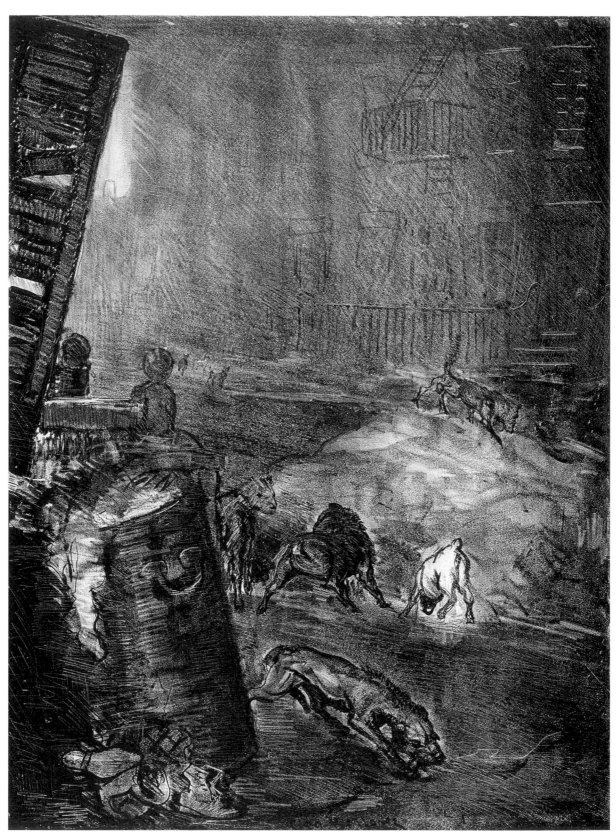

1. *Hungry Dogs, Second Stone* [first state of two], 1916 (M. 1B)

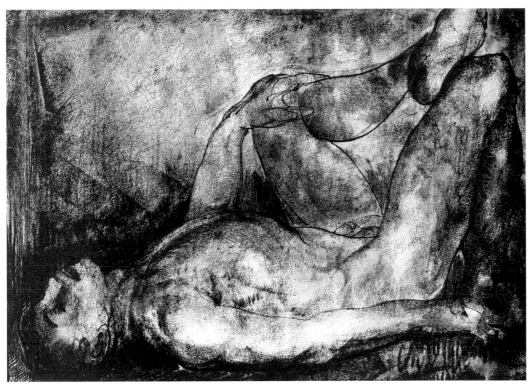

2. *Man on His Back, Nude* [second state of two], ca. 1916 (M. 3)

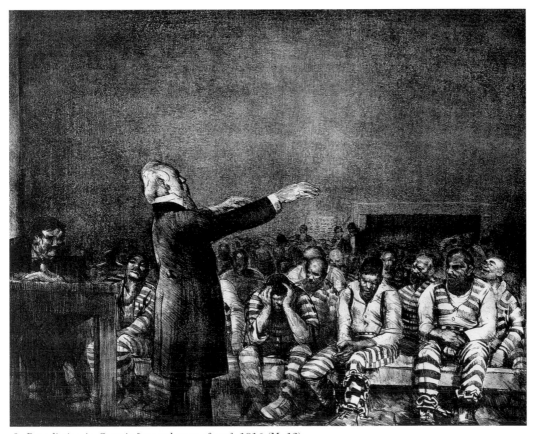

3. *Benediction in Georgia* [second state of two], 1916 (M. 12)

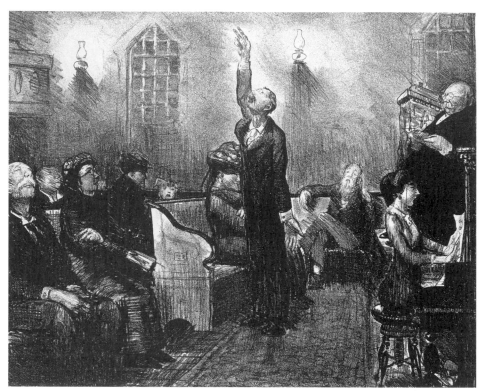

4. *Prayer Meeting, First Stone*, 1916 (M. 13)

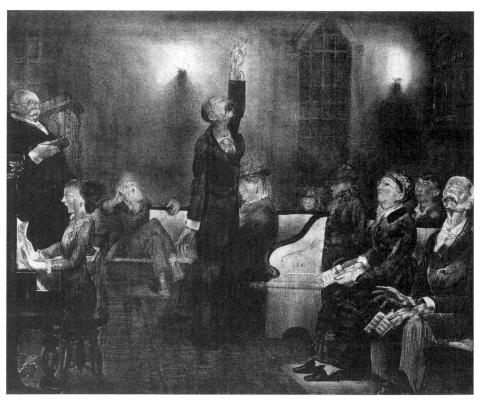

5. *Prayer Meeting, Second Stone*, 1916 (M. 14)

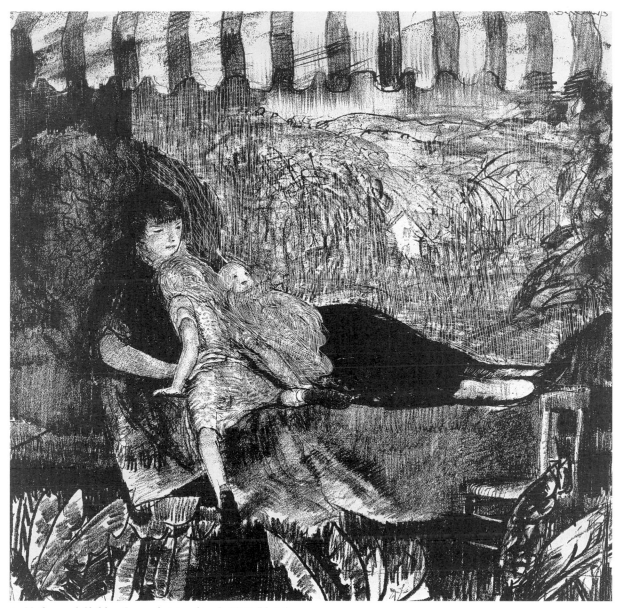

6. *Mother and Children* [second state of two], 1916 (M. 16)

7. *The Jury* [third state of three], 1916 (M. 17)

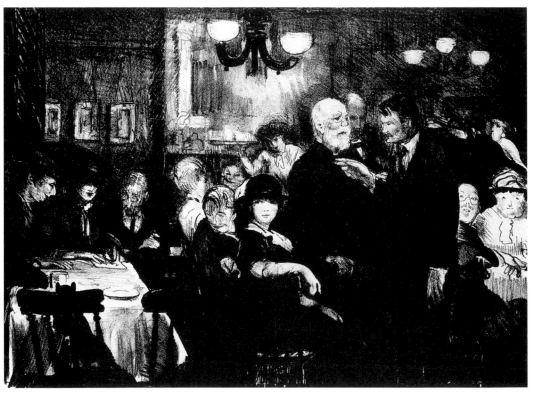

8. *Artists' Evening*, 1916 (M. 19)

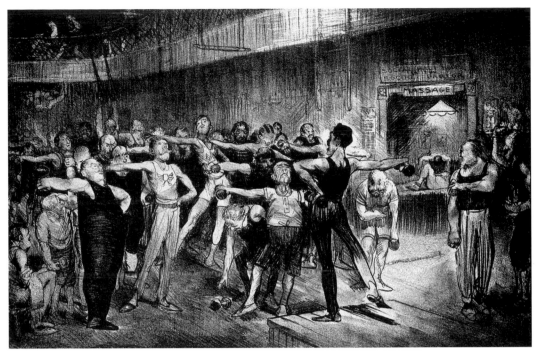

9. *Business-Men's Class,* 1916 (M. 20)

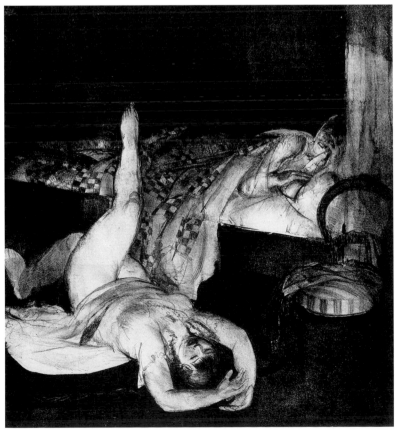

10. *Reducing, Large, Second Stone,* 1916 (M. 22)

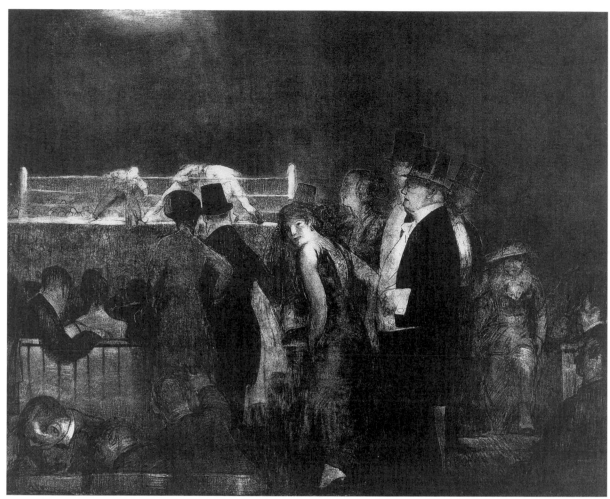

11. *Preliminaries,* 1916 (M. 24)

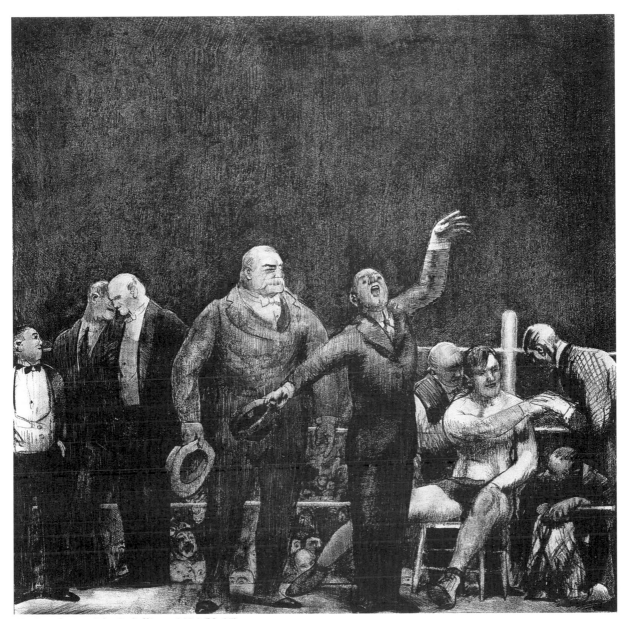

12. *Introducing John L. Sullivan,* 1916 (M. 27)

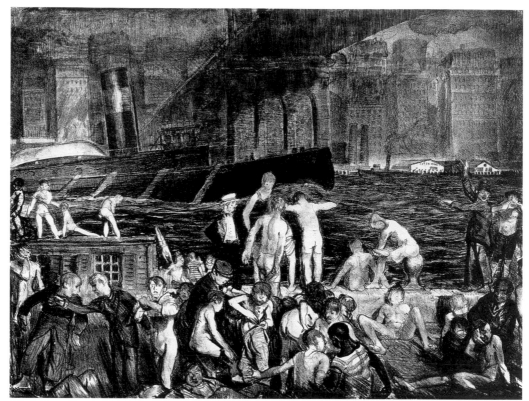

13. *Splinter Beach*, 1916 (M. 28)

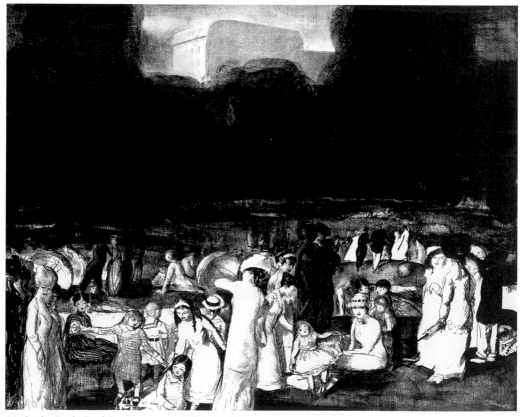

14. *In the Park, Dark* [variant state], 1916 (M. 30)

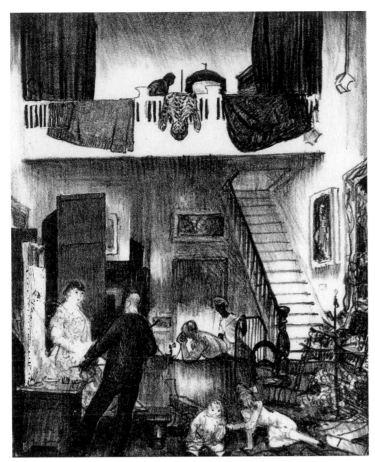

15. *The Studio, Christmas 1916*, 1916 (M. 35)

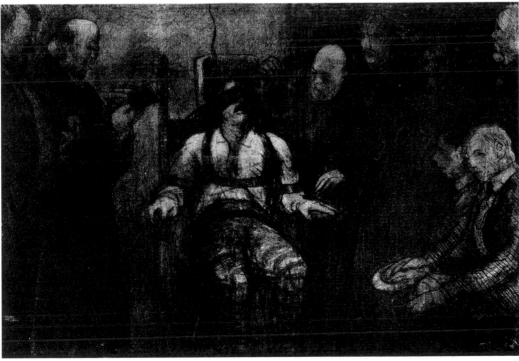

16. *Electrocution* [third state of five], 1917 (M. 42)

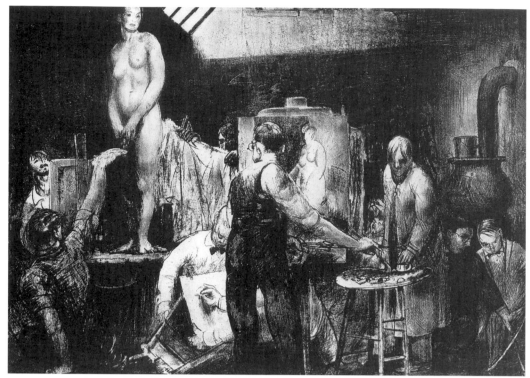

17. *The Life Class, First Stone* [second state of two], 1917 (M. 43)

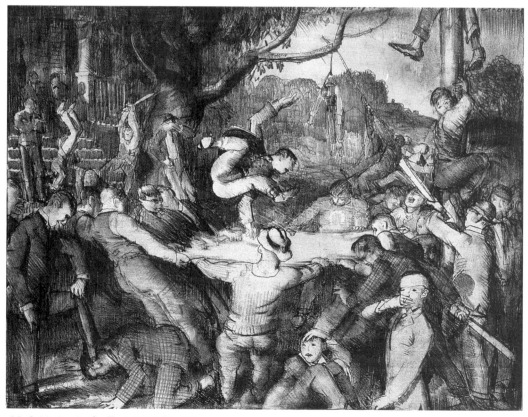

18. *Initiation in the Frat*, 1917 (M. 44)

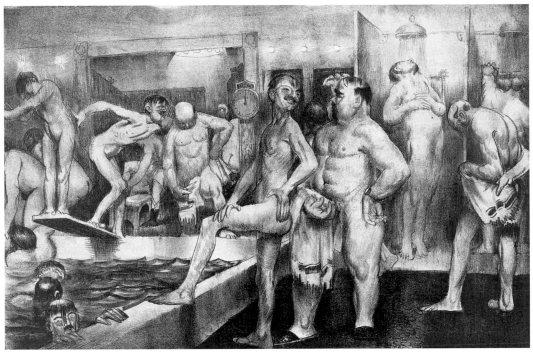

19. *The Shower-Bath* [first state of three], 1917 (M. 45)

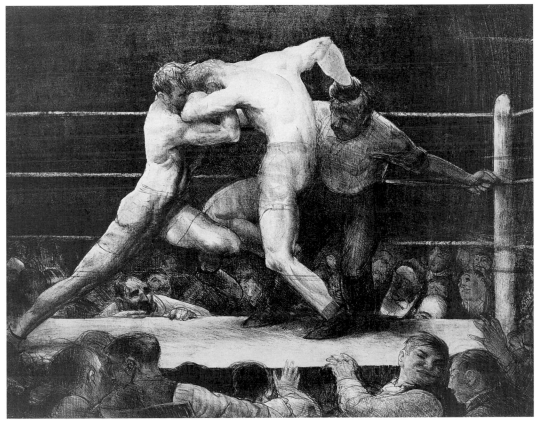

20. *A Stag at Sharkey's*, 1917 (M. 46)

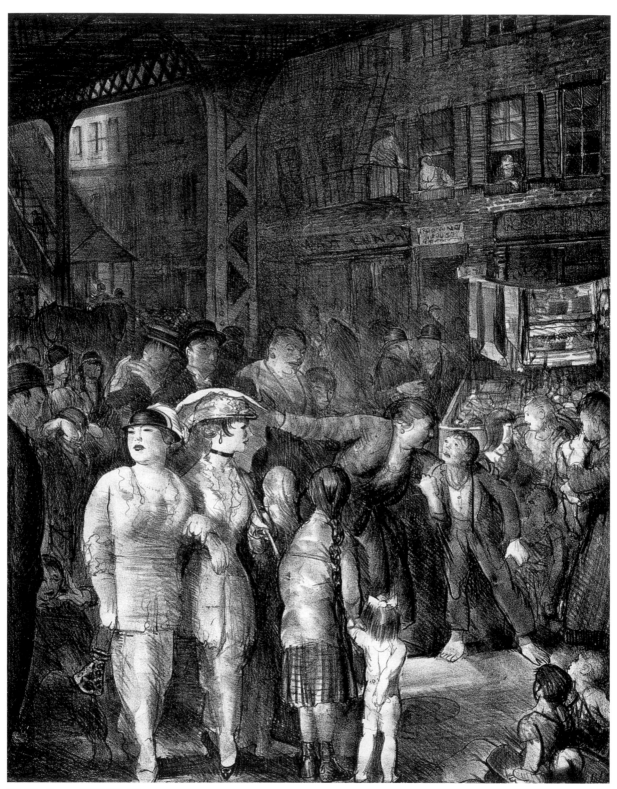

21. *The Street*, 1917 (M. 47)

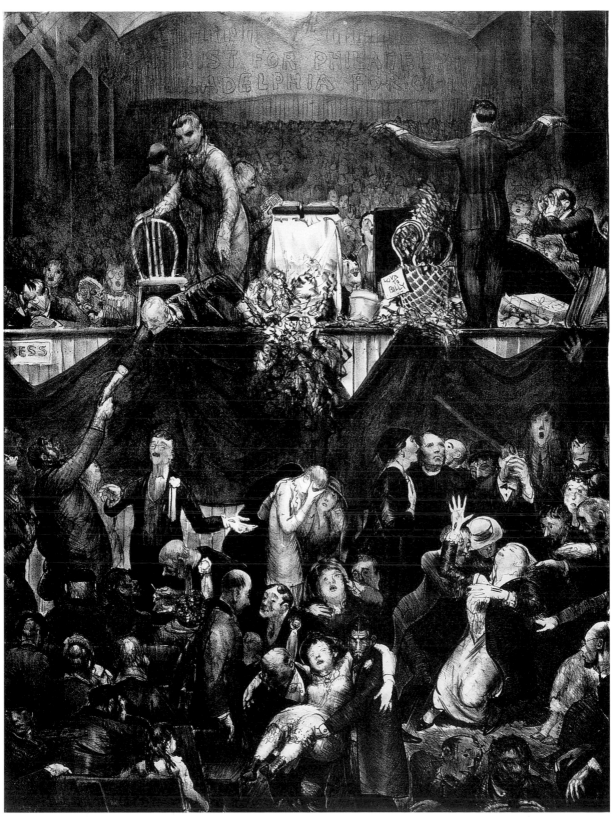

22. *The Sawdust Trail* [first state of two], 1917 (M. 48)

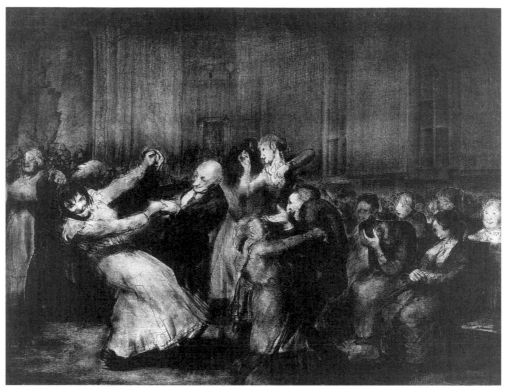

23. *Dance in a Madhouse,* 1917 (M. 49)

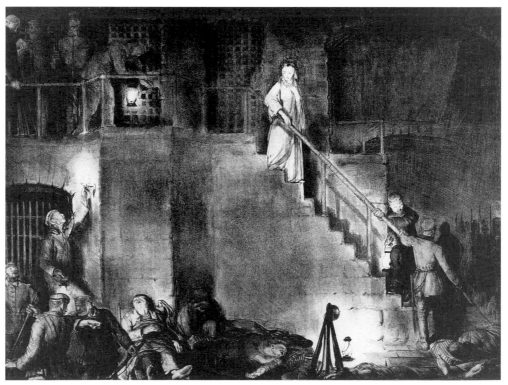

24. *Murder of Edith Cavell* (from the *War* series), 1918 (M. 53)

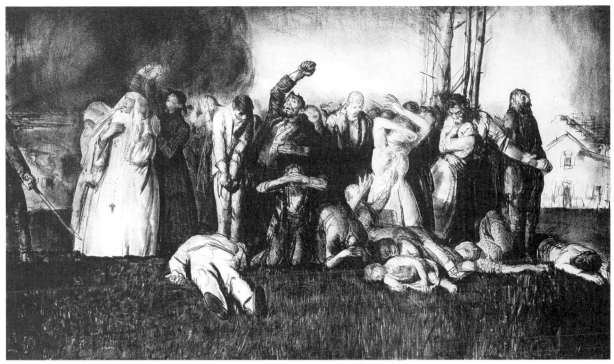

25. *Massacre at Dinant* (from the *War* series), 1918 (M. 54)

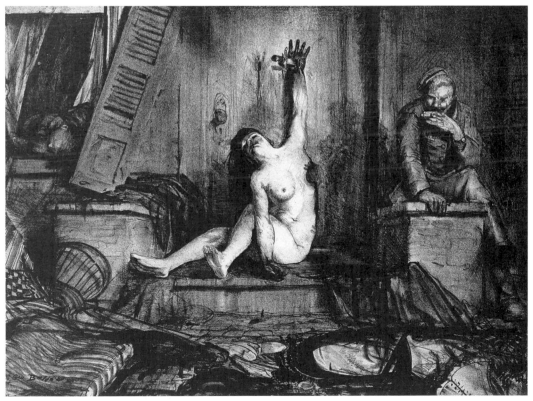

26. *The Cigarette* (from the *War* series), 1918 (M. 57)

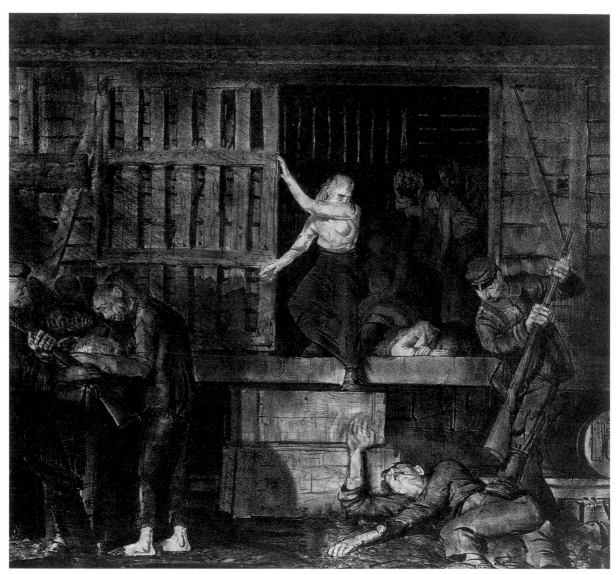

27. *The Return of the Useless* (from the *War* series), 1918 (M. 67)

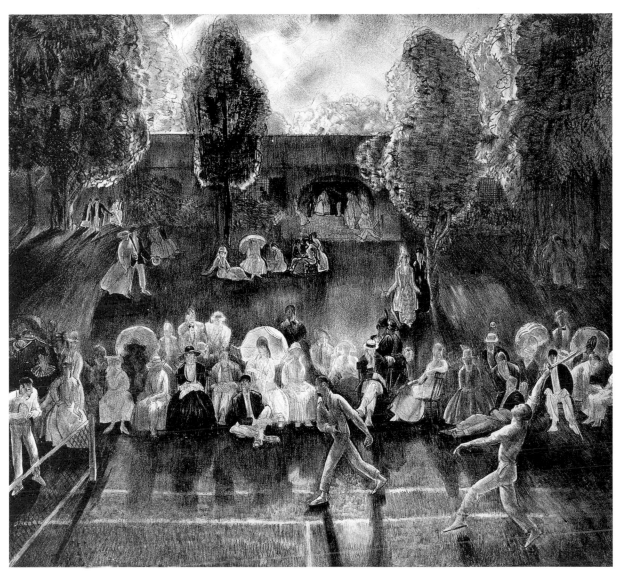

28. *Tennis*, 1920 (M. 71)

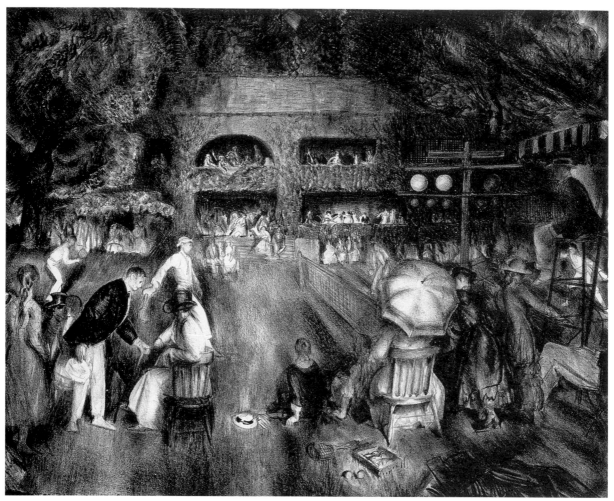

29. *The Tournament*, 1920 (M. 72)

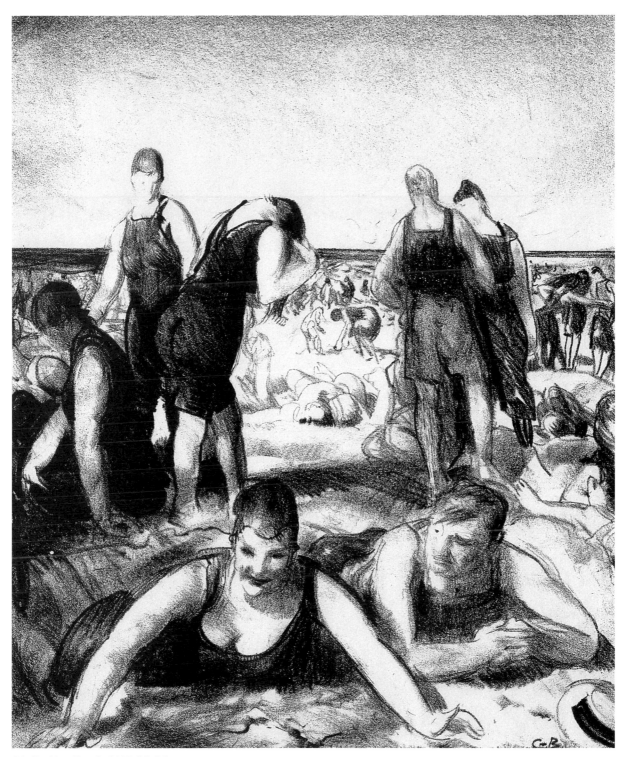

30. *Bathing Beach,* 1921 (M. 86)

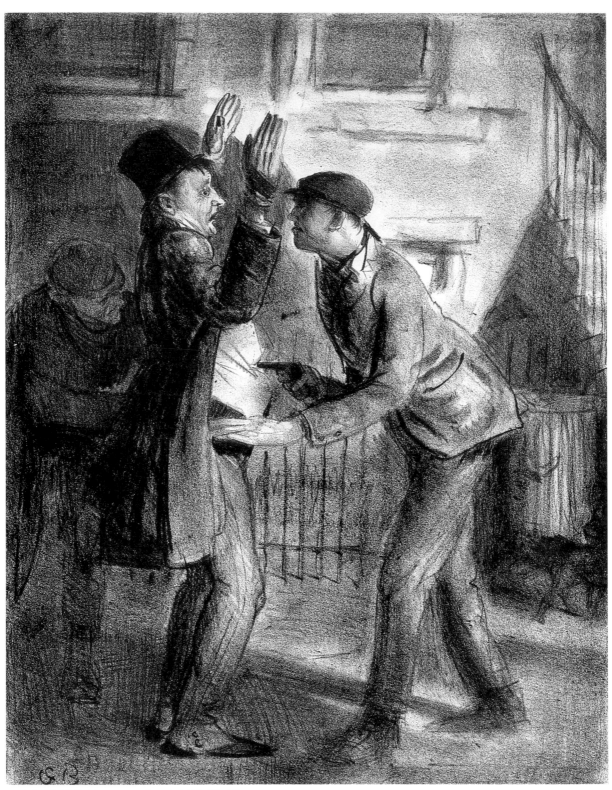

31. *The Hold-Up* [first state of two], 1921 (M. 89)

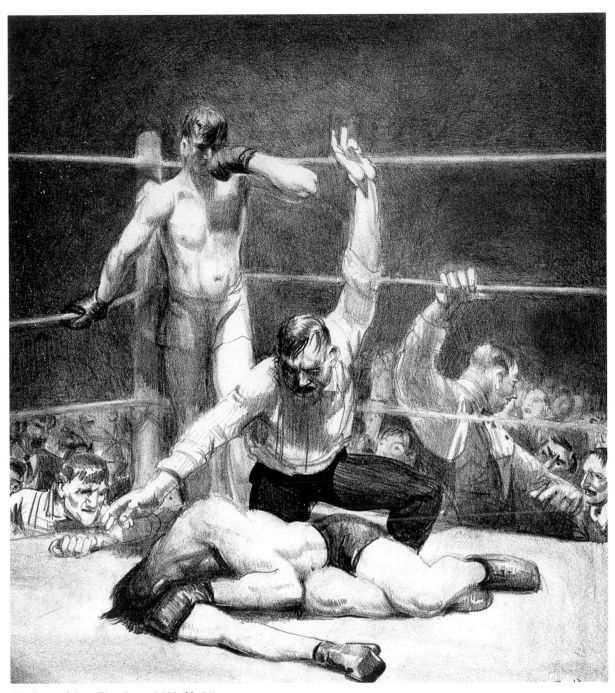

32. *Counted Out, First Stone*, 1921 (M. 94)

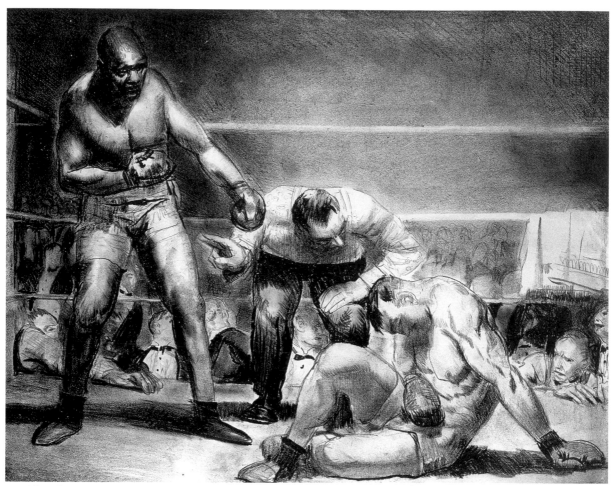

33. *The White Hope*, 1921 (M. 96)

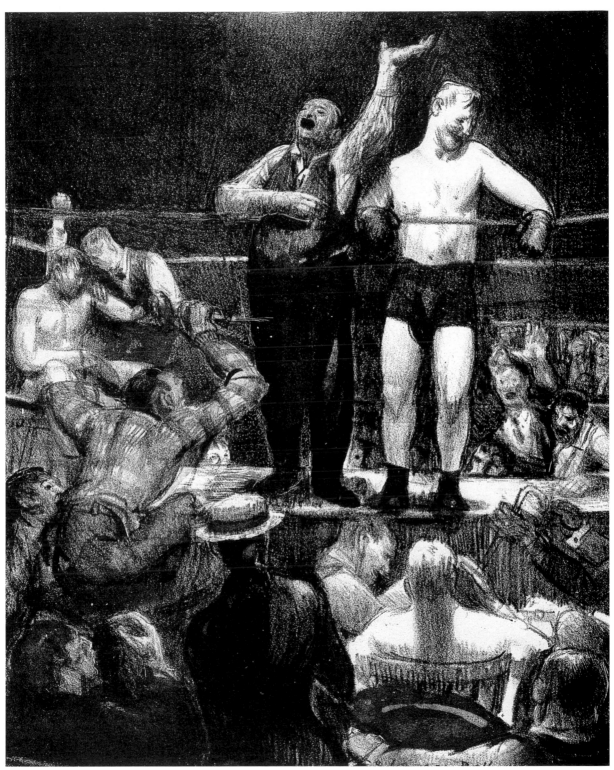

34. *Introductions,* 1921 (M. 97)

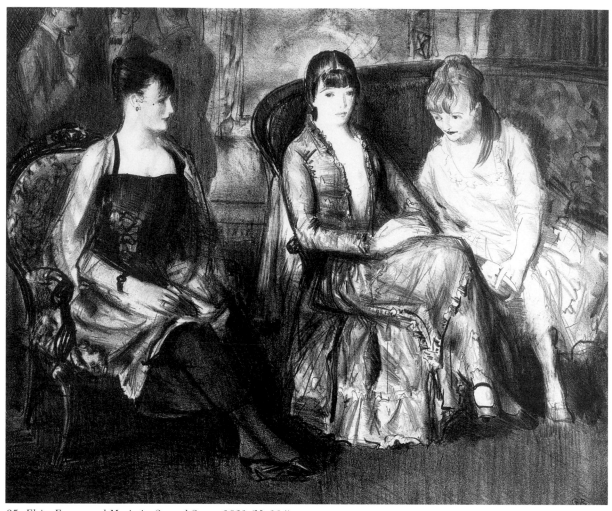

35. *Elsie, Emma and Marjorie, Second Stone*, 1921 (M. 104)

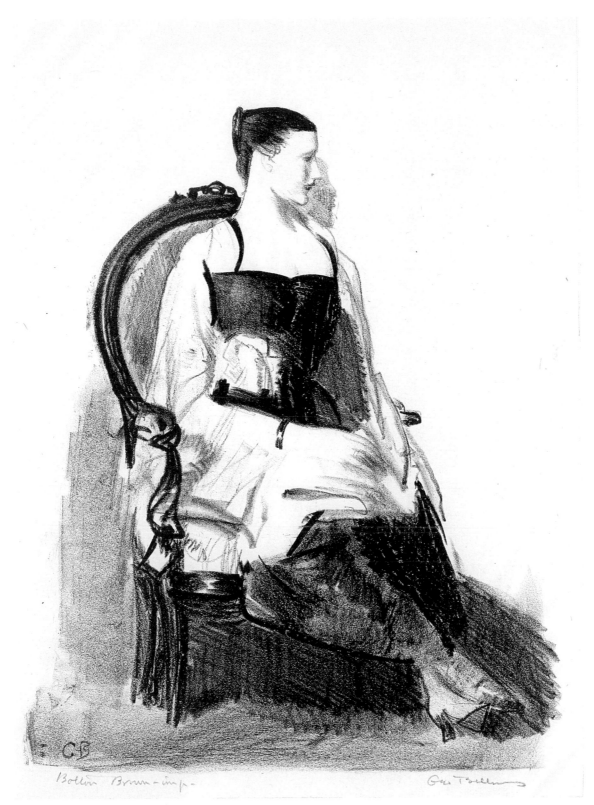

36. *Elsie, Figure*, 1921 (M. 109)

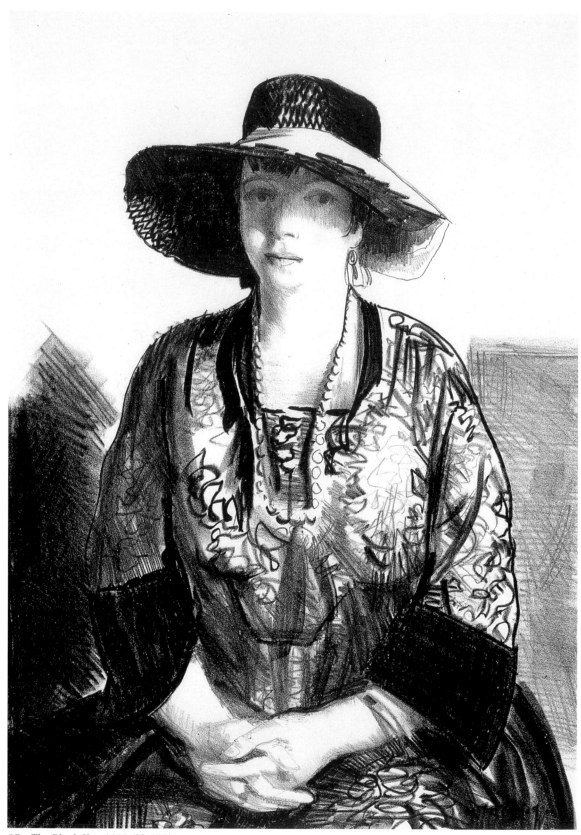

37. *The Black Hat*, 1921 (M. 113)

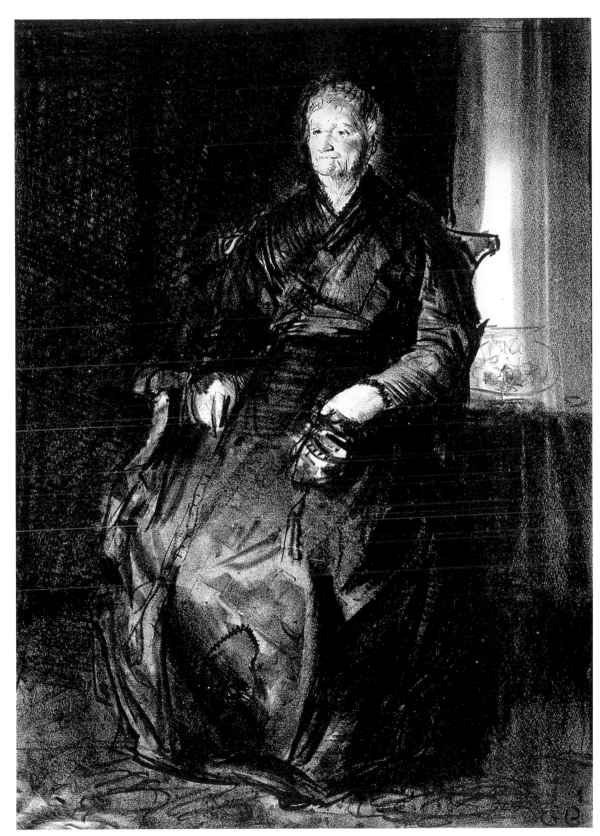

38. *Study of My Mother, First Stone,* 1921 (M. 122)

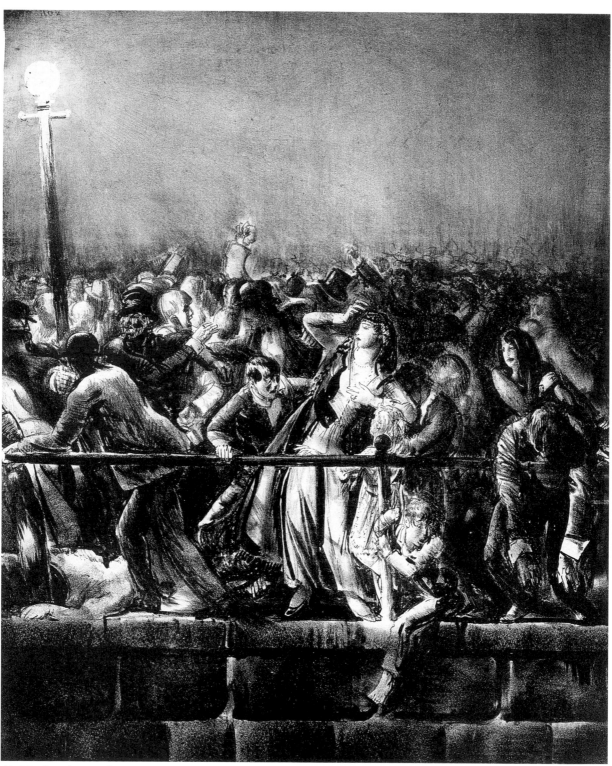

48. *The Crowd* [second state of two] (from the *Men Like Gods* series), 1923 (M. 162)

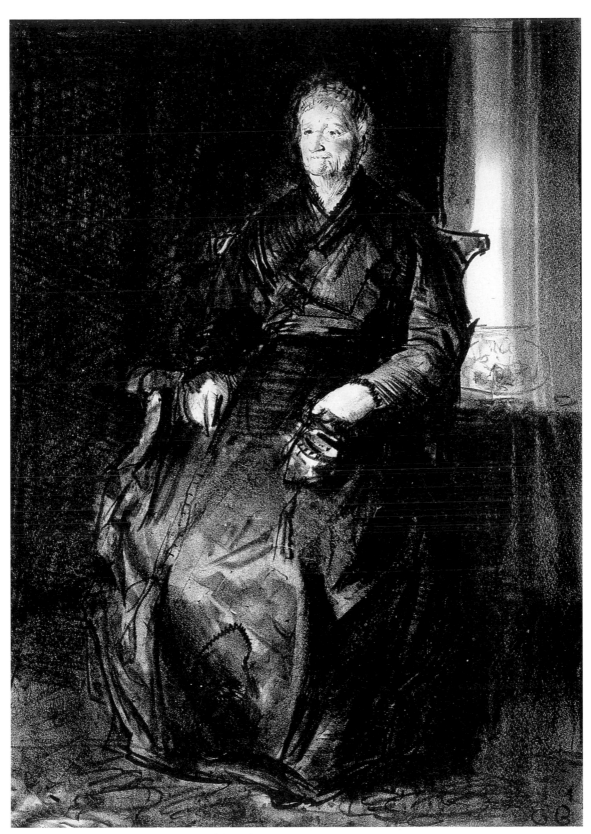

38. *Study of My Mother, First Stone*, 1921 (M. 122)

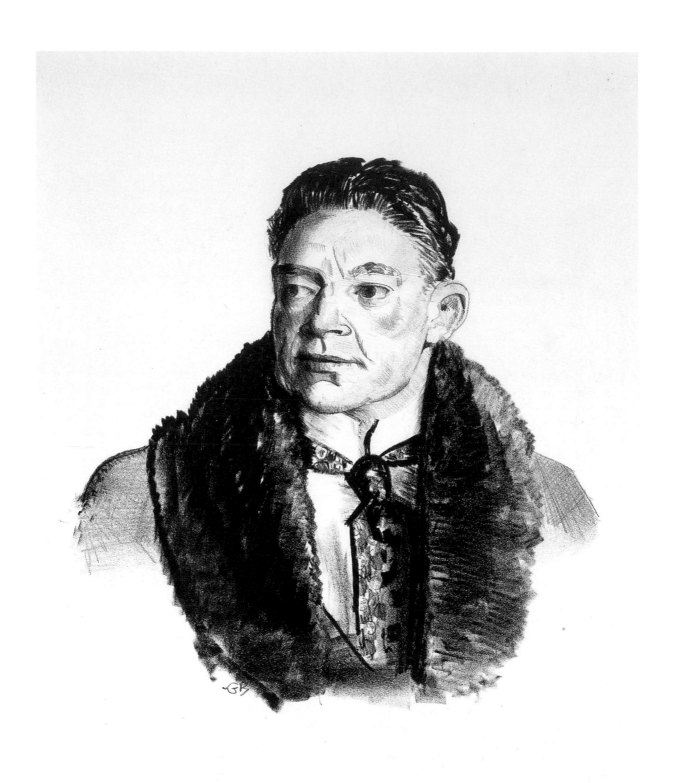

39. *Portrait of Robert Aitken, Second Stone, 1921* (M. 127)

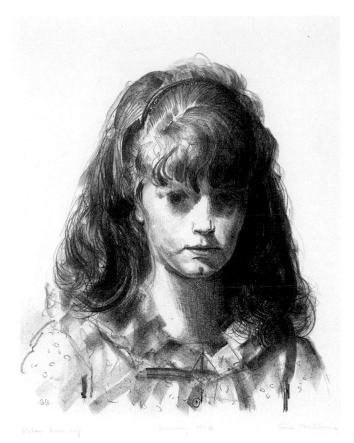

40. *Anne 1923*, 1923 (M. 137)

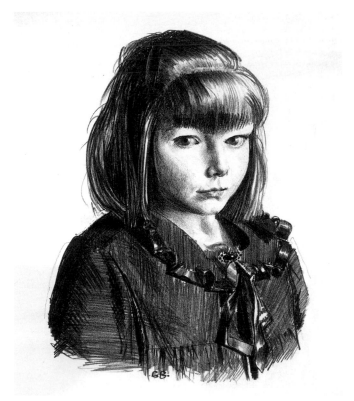

41. *Jean 1923*, 1923 (M. 138)

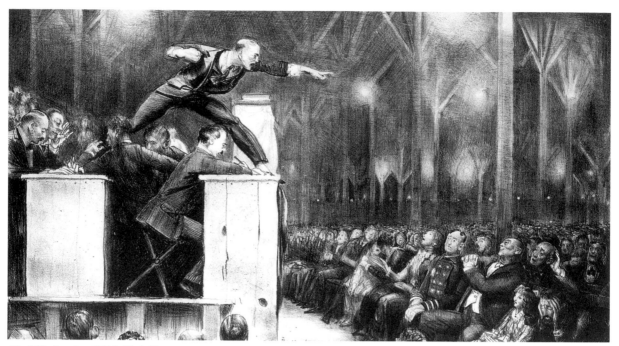

42. *Billy Sunday,* 1923 (M. 143)

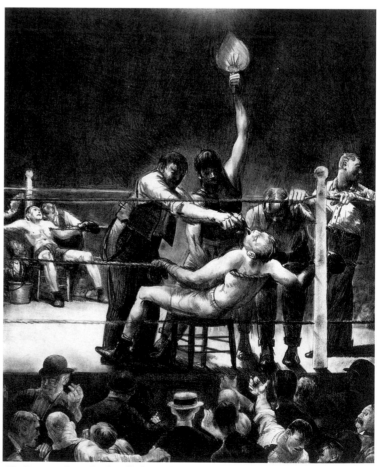

43. *Between Rounds, Small, Second Stone,* 1923 (M. 144)

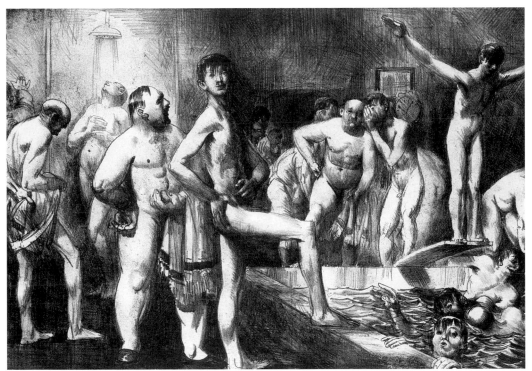

44. *Business-Men's Bath,* 1923 (M. 145)

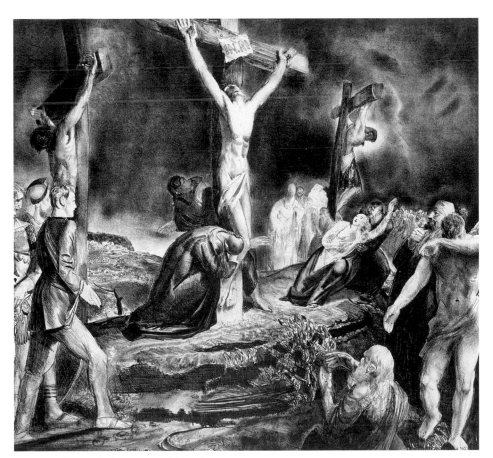

45. *Crucifixion of Christ,* 1923 (M. 146)

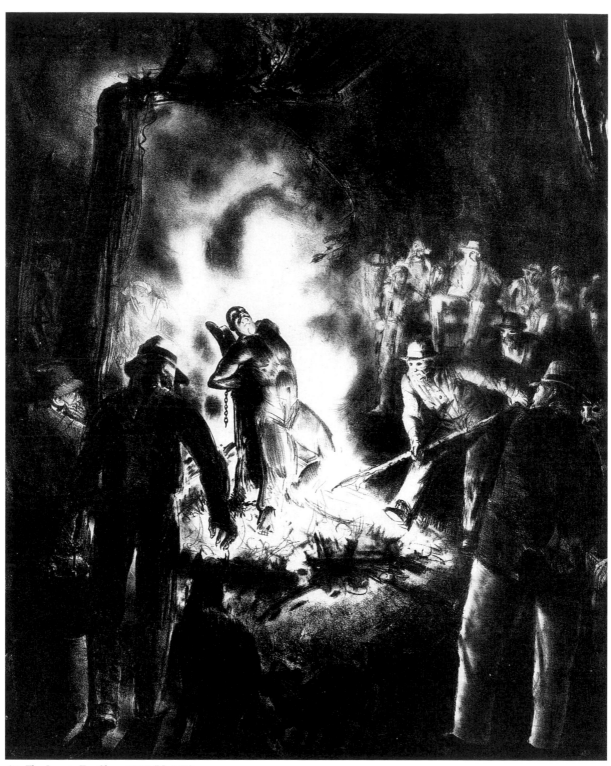

46. *The Law is Too Slow*, 1923 (M. 147)

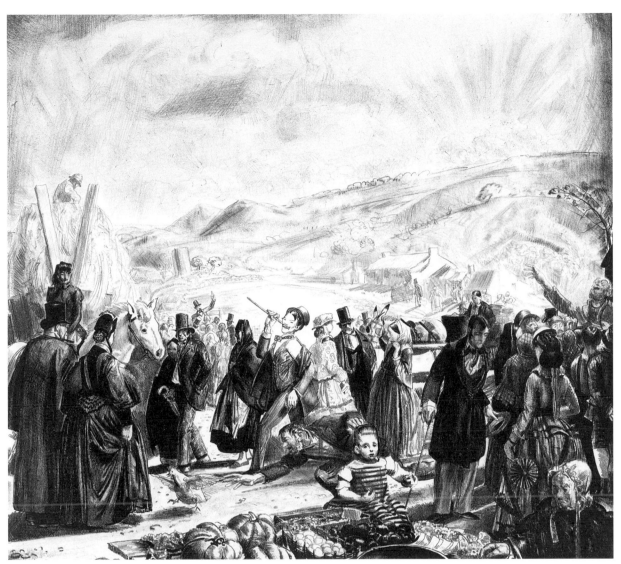

47. *The Irish Fair* (from *The Wind Bloweth* series), 1923 (M. 153)

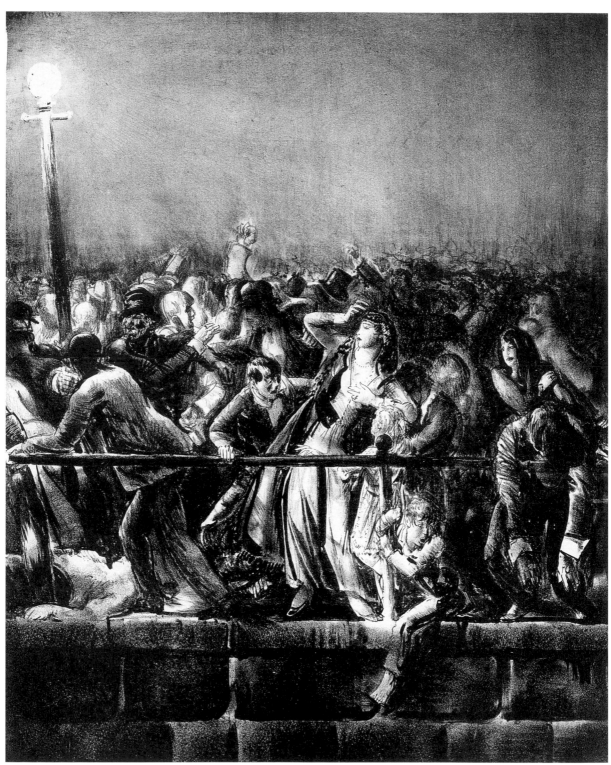

48. *The Crowd* [second state of two] (from the *Men Like Gods* series), 1923 (M. 162)

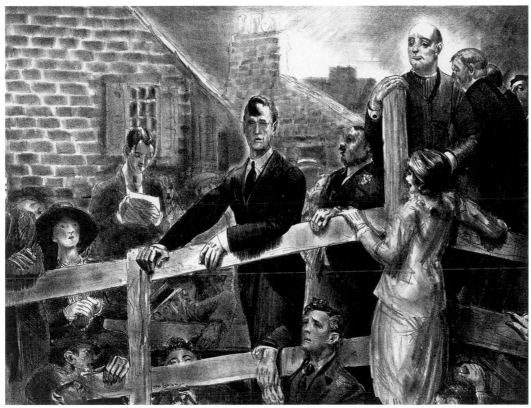

49. *The Appeal to the People*, 1923-24 (M. 167)

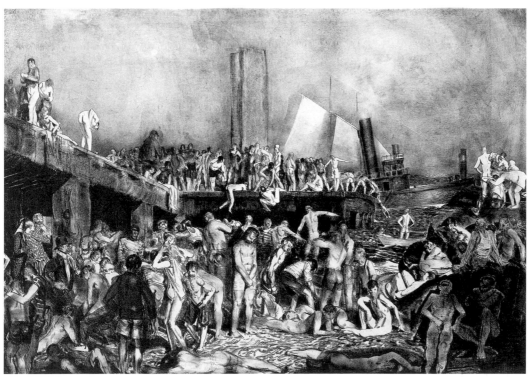

50. *River-Front*, 1923-24 (M. 168)

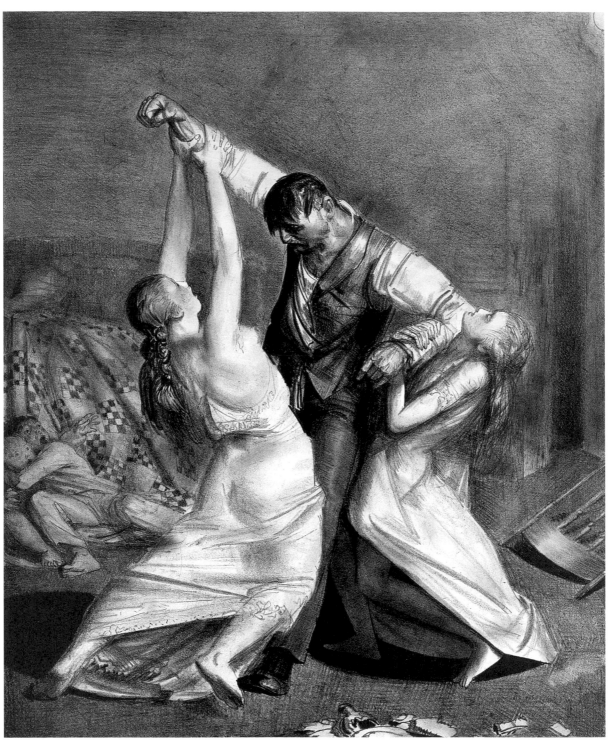

51. *The Drunk, Second Stone*, 1923-24 (M. 169B)

52. *Nude Study, Classic on a Couch*, 1923-24 (M. 170)

53. *Nude Study, Girl Sitting on Flowered Cushion*, 1923-24 (M. 172)

54. *Nude Study, Woman Lying Prone*, 1923-24 (M. 174)

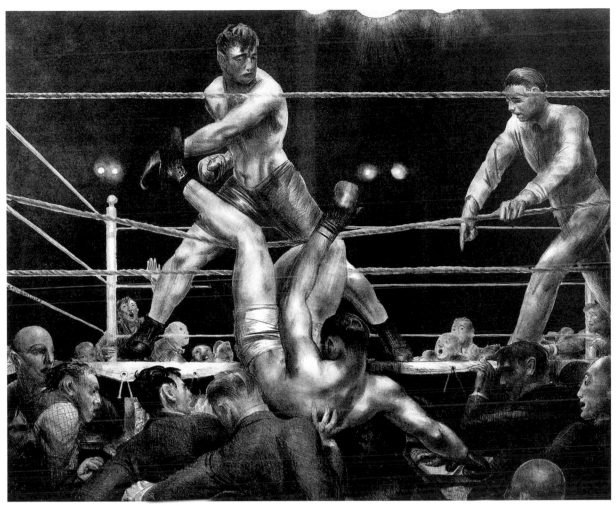

55. *Dempsey and Firpo*, 1923-24 (M. 181)

56. *Dempsey Through the Ropes*, 1923-24 (M. 182)

57. *Sixteen East Gay Street,* 1923-24 (M. 183)

58. *Girl Fixing Her Hair,* 1923-24 (M. 184)

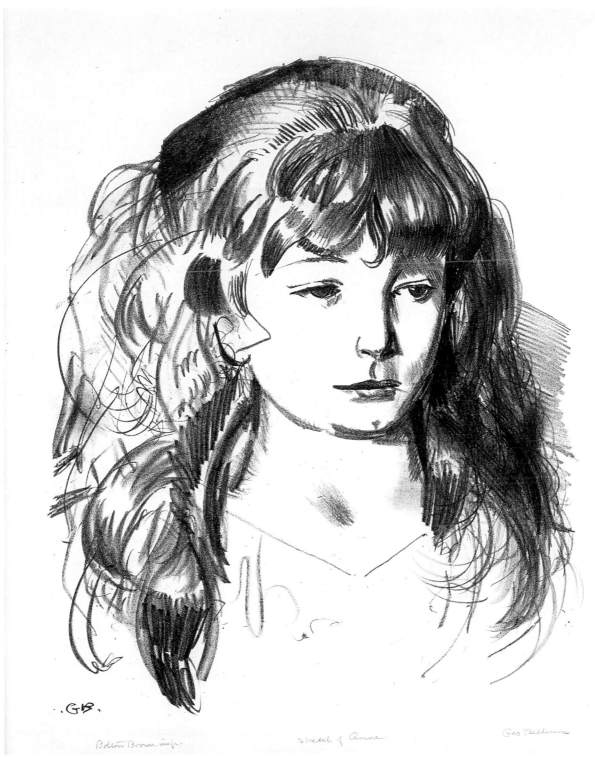

Bolton Brown, imp. Sketch of Anne Geo Bellows

59. *Sketch of Anne*, 1923-24 (M. 186)

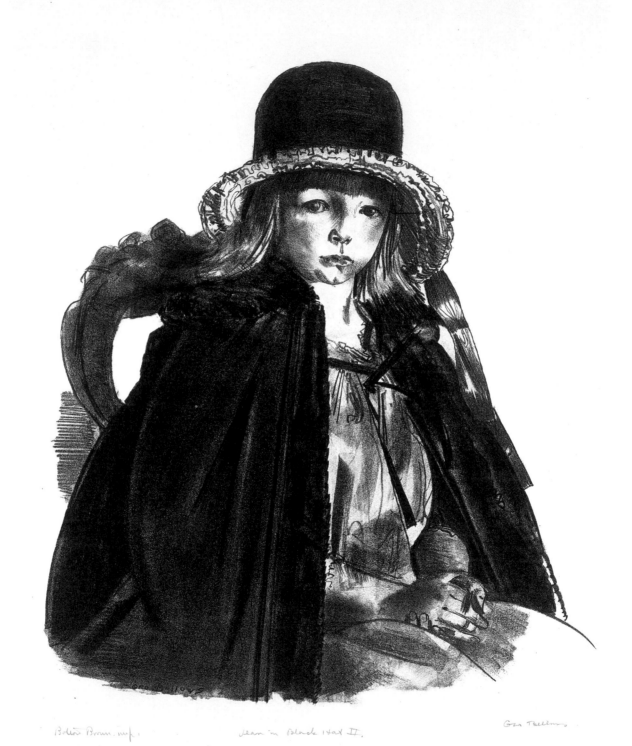

Jean in Black Hat II.

Geo Bellows

60. *Jean in a Black Hat* [second state of two], 1923-24 (M. 187)

CHECKLIST OF BELLOWS LITHOGRAPHS AT THE SAN DIEGO MUSEUM OF ART

1. *Hungry Dogs, Second Stone* [first state of two]
 1916
 13 5/16 x 9 7/8 in. (33.8 x 25.1 cm)
 Edition of at least 47
 Mason 1B; Bellows 98
 Museum purchase, 1997:7

2. *Man on His Back, Nude* [second state of two]
 ca. 1916
 8 1/2 x 11 5/8 in. (21.6 x 29.5 cm)
 Edition of at least 19 (both states combined)
 Mason 3; Bellows 119
 Museum purchase, 1996:22

3. *Benediction in Georgia* [second state of two]
 1916
 16 1/8 x 20 in. (41 x 50.8 cm)
 Edition of 80
 Mason 12; Bellows 135
 Museum purchase, 1997:8

4. *Prayer Meeting, First Stone*, 1916
 17 7/8 x 21 7/8 in. (45.4 x 55.6 cm)
 Edition of 77
 Mason 13; Bellows 38
 Museum purchase, 1997:9

5. *Prayer Meeting, Second Stone*, 1916
 18 7/16 x 22 1/8 in. (46.8 x 56.2 cm)
 Edition of at least 47
 Mason 14; Bellows 39
 Museum purchase, 1997:10

6. *Mother and Children* [second state of two], 1916
 11 1/8 x 11 1/4 in. (28.3 x 28.6 cm)
 Edition of 68 (both states combined)
 Mason 16; Bellows 164
 Museum purchase, 1997:11

7. *The Jury* [third state of three], 1916
 12 1/8 x 16 1/4 in. (30.8 x 41.3 cm)
 Edition of possibly 50 (all states combined)
 Mason 17; Bellows 158
 Museum purchase, 1997:12

8. *Artists' Evening*, 1916
 8 13/16 x 12 13/16 in. (22.4 x 32.5 cm)
 Edition of 65
 Mason 19; Bellows 34
 Museum purchase, 1997:13

9. *Business-Men's Class*, 1916
 11 9/16 x 17 1/4 in. (29.4 x 43.8 cm)
 Edition of 64
 Mason 20; Bellows 128
 Gift of Mr. and Mrs. Edwin S. Larsen, 1986:63

10. *Reducing, Large, Second Stone*, 1916
 17 7/8 x 17 in. (45.4 x 43.2 cm)
 Edition of 8
 Mason 22; Bellows 151
 Bequest of Earle W. Grant, 1972:7

11. *Preliminaries*, 1916
 15 3/4 x 19 1/2 in. (40 x 49.5 cm)
 Edition of 67
 Mason 24; Bellows 21
 Museum purchase, 1997:14

12. *Introducing John L. Sullivan*, 1916
 20 1/2 x 20 11/16 in. (52.1 x 52.6 cm)
 Edition of 54
 Mason 27; Bellows 106
 Museum purchase, 1997:15

13. *Splinter Beach*, 1916
 15 x 19 3/4 in. (38.1 x 50.2 cm)
 Edition of 70
 Mason 28; Bellows 63
 Museum purchase, 1998:85

14. *In the Park, Dark* [variant state], 1916
 16 7/8 x 21 1/8 in. (42.9 x 53.7 cm)
 Edition of possibly 81
 (including working proofs and
 variant states)
 Mason 30; Bellows 49
 Museum purchase, 1997:16

15. *The Studio, Christmas 1916*, 1916
 5 9/16 x 4 11/32 in. (14.1 x 11 cm)
 Edition unknown
 Mason 35; Bellows 159
 Gift of Mr. and Mrs. Edwin S. Larsen,
 1986:64

16. *Electrocution* [third state of five], 1917
 8 1/8 x 11 5/8 in. (20.6 x 29.5 cm)
 Edition of 51 (all states combined)
 Mason 42; Bellows 55
 Museum purchase, 1998:3

17. *The Life Class, First Stone*
 [second state of two]
 1917
 13 13/16 x 19 3/16 in. (35.1 x 48.7 cm)
 Edition of 49
 Mason 43; Bellows 193
 Museum purchase, 1997:17

18. *Initiation in the Frat*, 1917
 10 3/16 x 12 3/4 in. (25.9 x 32.4 cm)
 Edition of 16
 Mason 44; Bellows 176
 Museum purchase, 1998:88

19. *The Shower-Bath* [first state of three]
 1917
 15 7/8 x 23 3/4 in. (40.3 x 60.3 cm)
 Edition of 36 (all states combined)
 Mason 45; Bellows 99
 Museum purchase, 1998:4

20. *A Stag at Sharkey's*, 1917
 18 1/2 x 23 3/4 in. (47 x 60.3 cm)
 Edition of 99
 Mason 46; Bellows 71
 Museum purchase with funds from the
 Helen M. Towle Bequest, 1940:65

21. *The Street*, 1917
 19 1/16 x 15 1/4 in. (48.4 x 38.7 cm)
 Edition of 54
 Mason 47; Bellows 9
 Museum purchase, 1997:18

22. *The Sawdust Trail* [first state of two], 1917
 27 x 20 in. (68.6 x 50.8 cm)
 Edition of 65 (both states combined)
 Mason 48; Bellows 76
 Museum purchase, 1997:19

23. *Dance in a Madhouse*, 1917
 18 1/2 x 24 3/16 in. (47 x 61.4 cm)
 Edition of at least 77
 Mason 49; Bellows 92
 Museum purchase, 1997:20

24. *Murder of Edith Cavell* (from the *War* series)
 1918
 18 5/8 x 24 3/4 in. (47.3 x 62.9 cm)
 Edition of 103
 Mason 53; Bellows 11
 Museum purchase, 1997:21

25. *Massacre at Dinant* (from the *War* series)
 1918
 17 7/8 x 29 7/8 in. (45.4 x 75.9 cm)
 Edition of possibly 80
 Mason 54; Bellows 185
 Museum purchase, 1997:22

26. *The Cigarette* (from the *War* series), 1918
 14 7/8 x 19 3/8 in. (37.8 x 49.2 cm)
 Edition unknown
 Mason 57; Bellows 183
 Museum purchase, 1997:23

27. *The Return of the Useless* (from the *War* series)
 1918
 19 7/8 x 21 1/2 in. (50.5 x 45.6 cm)
 Edition of at least 72
 Mason 67; Bellows 149
 Museum purchase, 1998:5

28. *Tennis*, 1920
 18 1/4 x 19 15/16 in. (46.4 x 50.6 cm)
 Edition of 63
 Mason 71; Bellows 189
 Museum purchase, 1997:24

29. *The Tournament*, 1920
 14 7/8 x 18 1/4 in. (37.8 x 46.4 cm)
 Edition of 63
 Mason 72; Bellows 103
 Museum purchase, 1997:25

30. *Bathing Beach*, 1921
 8 3/8 x 7 in. (21.3 x 17.8 cm)
 Edition of 22
 Mason 86; Bellows 18
 Museum purchase, 1998:6

31. *The Hold-Up* [first state of two], 1921
11 1/8 x 8 5/8 in. (28.3 x 21.9 cm)
Edition of 42
Mason 89; Bellows 12
Museum purchase, 1997:26

32. *Counted Out, First Stone*, 1921
12 1/2 x 11 1/4 in. (31.8 x 28.6 cm)
Edition of 11
Mason 94; Bellows 107
Museum purchase, 1997:27

33. *The White Hope*, 1921
15 x 19 in. (38.1 x 48.3 cm)
Edition of 50
Mason 96; Bellows 44
Museum purchase, 1997:28

34. *Introductions*, 1921
8 1/2 x 7 in. (21.6 x 17.8 cm)
Edition of 57
Mason 97; Bellows 31
Museum purchase, 1997:29

35. *Elsie, Emma and Marjorie, Second Stone*
1921
11 3/8 x 13 7/8 in. (28.9 x 35.2 cm)
Edition of 64
Mason 104; Bellows 64
Museum purchase, 1997:30

36. *Elsie, Figure*, 1921
9 x 7 1/4 in. (22.9 x 18.4 cm)
Edition of 25
Mason 109; Bellows 59
Museum purchase, 1998:90

37. *The Black Hat*, 1921
13 x 9 in. (33 x 22.9 cm)
Edition of 55
Mason 113; Bellows 160
Museum purchase, 1997:31

38. *Study of My Mother, First Stone*, 1921
10 3/16 x 7 1/4 in. (25.9 x 18.4 cm)
Edition of 9
Mason 122; Bellows 129
Museum purchase, 1997:32

39. *Portrait of Robert Aitken, Second Stone*, 1921
9 3/4 x 9 1/4 in. (24.8 x 23.5 cm)
Edition of 23
Mason 127; Bellows 86
Museum purchase, 1997:33

40. *Anne 1923*, 1923
9 23/32 x 8 3/8 in. (24.7 x 21.3 cm)
Edition of 56
Mason 137; Bellows 57
Gift of the University Women's Club, 1927:6

41. *Jean 1923*, 1923
9 9/32 x 7 3/32 in. (23.6 x 18 cm)
Edition of 58
Mason 138; Bellows 65
Museum purchase, through exchange, 1952:60

42. *Billy Sunday*, 1923
9 x 16 1/4 in. (22.9 x 41.3 cm)
Edition of 60
Mason 143; Bellows 111
Museum purchase, 1997:34

43. *Between Rounds, Small, Second Stone*, 1923
18 3/16 x 14 3/4 in. (46.2 x 37.5 cm)
Edition of 42
Mason 144; Bellows 70
Museum purchase, 1997:35

44. *Business-Men's Bath*, 1923
11 3/4 x 17 in. (29.9 x 43.2 cm)
Edition of 43
Mason 145; Bellows 125
Museum purchase, 1997:36

45. *Crucifixion of Christ*, 1923
18 3/4 x 20 5/8 in. (47.6 x 52.4 cm)
Edition of 65
Mason 146; Bellows 97
Museum purchase, 1998:7

46. *The Law is Too Slow*, 1923
18 x 14 9/16 in. (45.7 x 37 cm)
Edition of 26
Mason 147; Bellows 73
Museum purchase, 1997:37

47. *The Irish Fair* (from *The Wind Bloweth* series)
1923
18 7/8 x 20 3/4 in. (47.9 x 52.7 cm)
Edition of 84
Mason 153; Bellows 68
Museum purchase, 1997:380

48. *The Crowd* [second state of two]
(from the *Men Like Gods* series)
1923
14 3/4 x 11 7/8 in. (37.5 x 30.2 cm)
Edition of 18 (both states combined)
Mason 162; Bellows 80
Museum purchase, 1998:2

49. *The Appeal to the People*, 1923-24
14 x 18 1/8 in. (35.6 x 46 cm)
Edition of 55
Mason 167; Bellows 115
Museum purchase, 1997:39

50. *River-Front*, 1923-24
15 x 21 in. (38.1 x 53.3 cm)
Edition of 51
Mason 168; Bellows 24
Museum purchase, 1998:86

51. *The Drunk, Second Stone*, 1923-24
15 5/8 x 13 in. (39.7 x 33 cm)
Edition of 50
Mason 169B; Bellows 60
Museum purchase, 1997:40

52. *Nude Study, Classic on a Couch*, 1923-24
10 1/8 x 12 1/2 in. (25.7 x 31.8 cm)
Edition of 32
Mason 170; Bellows 81
Museum purchase, 1998:8

53. *Nude Study, Girl Sitting on Flowered Cushion*
1923-24
8 x 9 3/8 in. (20.3 x 23.8 cm)
Edition unknown
Mason 172; Bellows 37
Museum purchase, 1998:9

54. *Nude Study, Woman Lying Prone*
1923-24
4 3/4 x 12 3/4 in. (12.1 x 32.3 cm)
Edition of 38
Mason 174; Bellows 108
Museum purchase, 1998:10

55. *Dempsey and Firpo*, 1923-24
18 1/16 x 22 1/4 in. (45.8 x 56.5 cm)
Edition of 103
Mason 181; Bellows 89
Gift of Mr. and Mrs. Edwin S. Larsen, 1986:62

56. *Dempsey Through the Ropes*, 1923-24
17 7/8 x 16 1/2 in. (45.4 x 41.9 cm)
Edition of 30
Mason 182; Bellows 90
Museum purchase, 1997:41

57. *Sixteen East Gay Street*, 1923-24
9 9/16 x 12 in. (24.3 x 30.5 cm)
Edition of 72
Mason 183; Bellows 84
Museum purchase, 1998:91

58. *Girl Fixing Her Hair*, 1923-24
8 3/4 x 7 1/16 in. (22.2 x 17.9 cm)
Edition of 22
Mason 184; Bellows 184
Museum purchase, 1997:42

59. *Sketch of Anne*, 1923-24
10 x 8 1/4 in. (25.4 x 22.2 cm)
Edition of 42
Mason 186; Bellows 51
Gift of Mr. and Mrs. Robert A. Hoehn,
1998:108

60. *Jean in a Black Hat* [second state of two]
1923-24
10 5/8 x 9 1/4 in. (27 x 23.5 cm)
Edition of 31
Mason 187; Bellows 45
Museum purchase, 1997:43

INDEX OF LITHOGRAPHS

INDEX OF PAINTINGS, DRAWINGS, ETCHINGS, MURALS, AND MONOTYPES

INDEX OF PROPER NAMES